nick vandome

LONDON
by Smartphone

In easy steps is an imprint of In Easy Steps Limited
16 Hamilton Terrace · Holly Walk · Leamington Spa
Warwickshire · United Kingdom · CV32 4LY
www.ineasysteps.com

Notice of Liability
Every effort has been made to ensure that this book contains accurate and
current information. However, In Easy Steps Limited and the author shall
not be liable for any loss or damage suffered by readers as a result of any
information contained herein.

Trademarks
All trademarks are acknowledged as belonging to their respective
companies.

In Easy Steps Limited supports The Forest Stewardship Council (FSC), the
leading international forest certification organisation. All our titles that are
printed on Greenpeace approved FSC certified paper carry the FSC logo.

MIX
Paper from
responsible sources
FSC® C020837

Printed and bound in the United Kingdom

ISBN 978-1-84078-979-9

Contents

4 London Top Sights 57

1 Introducing the Guide

London by Smartphone *is the essential, innovative guidebook for the digital age, for getting the most out of a city break to London, with your smartphone as your travelling companion.*

This chapter explains the purpose of the guide and shows how it can be used to locate and photograph iconic – and less well-known – locations around the city, and also enjoy a range of different walks around London. It shows how to get the most out of the walks, with step-by-step details and including historical information, potential detours and refreshment stops.

The **what3words** *app is used throughout the book to identify locations for photos and walks, and there is a detailed look at the app, showing how to use it to identify locations, get directions to each reference point, and also save favourite locations so that you can quickly find them with a couple of taps.*

About this Guide

London by Smartphone is a guidebook for the digital age, to help you get the most out of a city break visit to one of the world's great cities.

The book focuses on two of the main areas that are undertaken on city breaks: photography and walking, and shows related information needed to explore all aspects of the city, from fun facts to places to eat and drink.

Photos

For each photo in the book, the **what3words** app is used to give a precise location from where to take a photo. **what3words** works by dividing the entire globe into three-metre squares (57 trillion in total) and giving each square a unique three-word designation. It is therefore possible to identify the exact spot where certain photos are taken: the book contains photos for each location and their **what3words** designation. (See pages 12-22 for details about using the **what3words** app.)

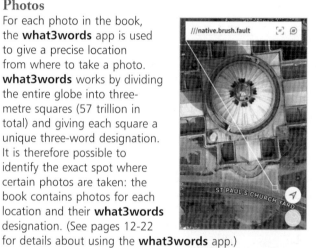

In addition, the exact direction to be facing when taking a photo is also listed. This is done using a compass app on a smartphone and, if there is not one on your smartphone already, one can be downloaded from either the Apple App Store or the Google Play Store. Follow the compass directions in the guide to be in the correct position to take a photo at the **what3words** location. The best time of day for taking a photo is also listed, to get the best possible lighting conditions (weather permitting).

...cont'd

The types of photos used in the book are covered in two categories: iconic, top sights shots to show postcard-type photos that people associate with the location; and more obscure, hidden photos that will help you discover hidden gems around the city.

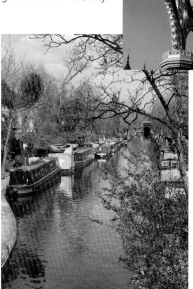

Each photo has directions for getting to the required location (including the nearest London Underground Tube station), **what3words** references, photo facts about items in the photo, nearby locations of restaurants, cafés and pubs, other nearby attractions, selfie spots, and other photos that can be captured from the same location.

Walking

If you choose carefully, walking can be a great way to see the sights of London and also absorb some of its character. The five walks in the book cover some of the top sights in the city, relaxing green open spaces, and areas that show some of the history of London's development. The walks are:

- Jubilee Loop Walk

- Thames Walk

- Hyde Park Walk

- *Monopoly* Walk

- Spitalfields Walk

The walks are detailed in a step-by-step process, which tracks the route of the walk and identifies notable features along the way. The length of each walk is listed, as well as the approximate number of steps (for those watching their step count each day). Each walk includes historical notes, refreshment stops and useful detours. The **what3words** app is used to provide directions and identify points of interest or importance along the walk; e.g.

11 Cross into Parliament Square Garden, at the crossing in Step 10, entering Parliament Square Garden at **angle.snap.fishery**

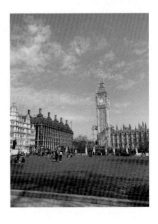

Symbols in this Guide

The symbols used the book are intended to provide additional information relating to a specific photo or the area in which it is located. The symbols are:

Nearest Tube station: This indicates the nearest Underground (Tube) station to the photo spot, which can save a lot of time and effort when travelling to the location.

Getting there: This includes directions for getting to the photo spot from the nearest Tube station.

///dance.hills.type

CONSTITUTION HILL

SPUR ROAD

what3words references are used for directions – e.g. **dance.hills.type** – to get to the location.

Photo fact: This contains useful, interesting or just fun information about items in the photo or nearby.

Nearby food and drink: This details restaurants, cafés and pubs that are near to the photo location so that you can stop for some refreshments before or after you take photos. Each establishment is on TripAdvisor, so its details and reviews can be checked as required.

Nearby attractions: This lists attractions that are near to the location of the photo spot. The attractions can be either modern or historical, and each one is given a **what3words** reference. The attractions cover all areas of London life to give a more varied sense of the city.

Selfie spot: This identifies options for taking selfies, with notable items in the background. This can be done with a selfie stick or just with your smartphone camera.

Using *what3words*

Finding locations and tourist attractions can be a time-consuming task when you are in a new city, and this could be time that you cannot afford if you are on a short city break. However, help is at hand with an app that can guide you to any location in a city, or anywhere in the world, through the simple use of combinations of three words.

The app is called **what3words** and it can be downloaded from the Apple App Store for an iPhone and

the Google Play Store for an Android smartphone.

what3words works on a simple but ingenious premise: it divides the whole globe into three-metre by three-metre squares and gives each of them a unique three-word designation. So, if you are standing near to Buckingham Palace, you can find your exact **what3words** location with a single tap of the app. Similarly, if you are given a **what3words** reference, you will be able to go to the exact location mentioned.

The photo sites and landmarks in this book are all described with their **what3words** location, and they can all be located exactly using the app.

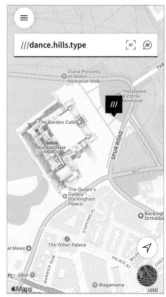

The **what3words** app uses a grid over a map view or a satellite view, and each square represents a three-metre by three-metre location. The maps can be zoomed in on or zoomed out from to see a location in more detail, or view it within the content of a larger area.

...cont'd

Finding your current location

The **what3words** app can be used to quickly find your current location and display its **what3words** description. To do this:

1 Open the **what3words** app

2 Tap on this button

3 The current location is displayed on the map, denoted by a square with a black outline (in map view)

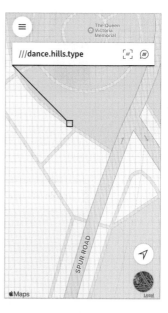

4 The **what3words** description is displayed in a text box at the top of the window

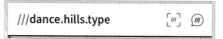

13

5 If you zoom out on the location (pinch inwards on the screen with thumb and forefinger), the location icon changes from a square with a black outline to a solid dark square, with the **what3words** logo

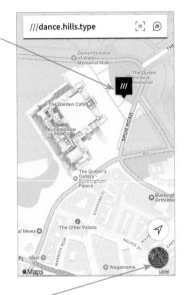

6 Tap on this button to see a satellite view (the location box outline turns white in this view)

Finding a *what3words* location

If you are provided with a **what3words** reference, such as the sites and locations throughout this book, it is a straightforward task to find the location:

1 Tap in the text box at the top of the window to access the Search box. If previous searches have been made these will be shown below the text box

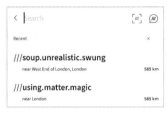

2 Enter the **what3words** reference with a full stop after the first two words but not after the last one. Suggestions that are similar to the reference are displayed below it. Tap on one of the suggestions or tap on the **Go** button to display the reference in the text box (pay particular attention when entering plurals)

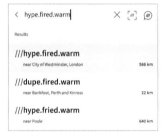

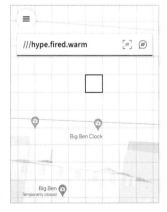

Finding named locations

Instead of using a **what3words** reference, it is also possible to find named locations, such as streets or landmarks:

1 Tap in the **what3words** Search box and enter a named location. Tap on one of the results to view the selected location

2 The location is displayed on the map, with its **what3words** reference displayed in the Search box

3 Pinch inwards on the screen with thumb and forefinger to zoom out on the location and view it in a wider context

4 Tap on this button to view a satellite map of the location

Scanning references

In addition to typing a **what3words** reference into the app to find a location, it is also possible to scan an existing reference, such as those in this book, using the app itself. To do this:

1 Open the **what3words** app and tap on this button in the text box at the top of the window

2 Position the scan box over a **what3words** reference (where possible, the **what3words** references in the book are produced on a single line, to make it easier to scan them)

3 Tap on one of the suggested **what3words** references

4 The location is shown on the current map type; e.g. map or satellite

Speaking references

what3words references can also be located by speaking three words into the app. To do this:

1 Open the **what3words** app and tap on this button in the text box at the top of the window

2 The app will ask for access to your device's microphone. Accept this and then speak the required three-word reference (punctuation is not required – just the words on their own)

3 Voice searching is not always an exact science. Possible matching options are listed. Tap on one to view its location, or tap on the Speech icon again to perform another voice search

Getting directions

Once you have found a **what3words** location, you can use the app to find directions to it from your current location. To do this:

1 Find the required location in the **what3words** app

2 Tap on the **Navigate** button at the bottom of the screen

3 Select an option for how you would like to navigate to the location – usually a maps app

4 Use the selected maps app to navigate to the location. Tap here to find directions to the location

...cont'd

5 The route is displayed. Tap on the **Go** button to start the directions. Tap here to select your mode of transport. Your location is marked on the route and this moves as you travel along the route

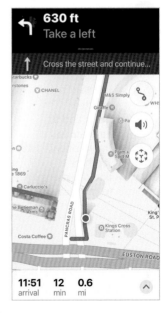

6 A spoken narration guides you along the route with directions. These change as you move along the route until you arrive at your destination

...cont'd

Saving favourites

If there are locations you want to visit regularly, you can save these as favourites so that you do not have to enter the **what3words** reference each time you want to view the location. To do this:

1 Find the required location in the **what3words** app. Favourite locations can be saved from anywhere, so they are saved and ready for when you visit the location

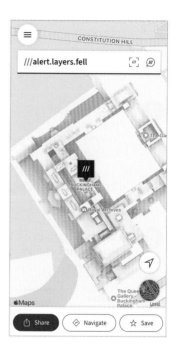

2 Tap on the **Save** button at the bottom of the screen

☆ Save

3 The location is saved to the **Favourites** section of the app, indicated by the **Saved** button

4 Tap on the **Menu** button in the top left-hand corner the screen to view all of your favourite locations

5 Tap on the **Saved locations** option

👤 Nick Vandome	>
★ Saved locations	>

6 Tap on the **Favourites** option

× Saved locations ⋯

My lists

♥ Favourites 1 >

＋ Add a new list

7 Tap on one of the options to view that location

‹ Favourites ⋯

68 locations | Updated 14/02/22
Created by you 🗺 Map

🖍

///alert.layers.fell

near London 586 km ⋯

8 Tap here and tap on the **Add Label** option

🏷 Add Label

9 Enter a label name for the location and tap on the tick icon

Add Label
Buckingham Palace ✓

10 The label is added to the location, to make it more easily recognisable

‹ Favourites ⋯

68 locations | Updated 14/02/22
Created by you 🗺 Map

🖍

///alert.layers.fell

near London 586 km ⋯
Buckingham Palace

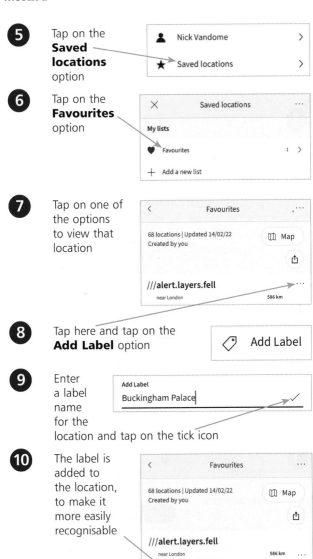

2 Smart London Essentials

London is a city that is bursting with possibilities for a city break. However, it is important to make the most of your time there, particularly as the size of London can be quite daunting if you do not plan your visit carefully. This chapter covers some essential information about London so that you can get a good understanding of the city, and what to do there, before you even arrive.

The chapter also details some of the history that has shaped the city as it is today and looks at some practical information for a city break in London, including: planning your time there; getting into the centre of London when you arrive; detailed information about using the London Underground (Tube) for getting around; some other city transport options such as walking and cycling; where to find free Wi-Fi; and some of the culinary delights that you can expect to find. Finally, there is information about what can be an essential service in a time of need – free public toilets!

All About London

It is hard not to be captivated by London: it has a natural vibrancy, it is steeped in history, and everywhere you look there are iconic locations or buildings. Some of the features of London that can be enjoyed during a city break or a longer stay include:

- World-renowned sights, such as Buckingham Palace, the Tower of London, and Big Ben.

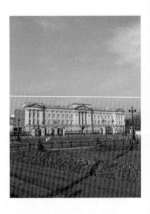

- Hidden gems around the city that may even make you forget about the main sights for a while, including the charming St. Dunstan in the East church and the stunning Painted Hall in the Old Royal Naval College in Greenwich.

- Relaxing green spaces in the heart of the city, such as the extensive Hyde Park and neighbouring Kensington Gardens.

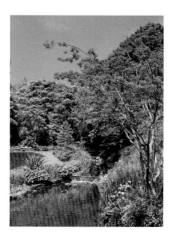

- A range of walking routes, covering everything from the main sights of London to the streets in the famous board game *Monopoly*.

- Stunning views of London from the Sky Garden.

- Modern architecture such as the Gherkin.

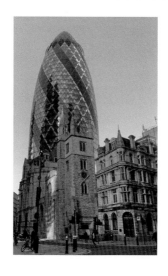

City Planning

One undeniable fact about London is that it is big – very big. With a population of over 9 million people for Greater London and an area of over 1,500 square kilometres (as opposed to the City of London, which is approximately 3 square kilometres at the heart of the capital), it is not a city that can be fully covered in a city break, or even several. However, there are two factors that can help you to get the most out of a city break to this thriving metropolis:

- Plan your trip carefully and identify what you want to do on each day of your trip. You do not have to stick to this rigidly and there can still be some room for some spontaneous activities, although it is best not to get too side-tracked. When you are planning your London city break, try to make the most out of specific areas when you are there. While the Tube can be put to good use for getting around (see below), it makes good sense to do as much as possible in one location. For instance, the area around the Monument Tube station contains several of the photo sights in this book, including the Great Fire Monument, St. Dunstan in the East, Leadenhall Market, the Sky Garden, the Gherkin, and London Stone, with St. Paul's Cathedral, the Tower of London and Tower Bridge a short walk away. Use a map of the city to identify locations you want to visit, and group them together and keep a note of your planned itinerary on your smartphone so that you always have it with you.

- Make the most out of the London Underground (the Tube). Due to the size of London, it makes good sense to travel around the city on the Tube, to get to different parts of the city. A Tube map can be accessed online and used to identify Tube services to take you to specific locations, the lines on which they travel, and any changes that have to be made on the route. The Tube is not only a great time-saving option, it is also a London experience in its own right and one not to be missed. See pages 32-35 for details about travelling by Tube.

Fire and Plague

One of the most notable characteristics of London is the resilience of its residents. This was never more apparent than during the 17th century, when the city was visited by the Great Plague and devastated by the Great Fire. On both occasions, London bounced back stronger and strove to develop a new and better version of the city.

The Great Plague lasted through 1665-66 and killed over 100,000 people, approximately 20% of the London population at the time. The plague in question was the Bubonic Plague and was carried by fleas on the numerous rats that inhabited the sewers of the city, and through debris that littered its streets. As with many public health events, it was the poorer residents of London who were the hardest hit, as they had to endure the most unsanitary living conditions. Many of the rich managed to leave the city for their country houses, leaving the rest of the population to their fate.

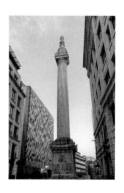

If the plague decimated the human population of London, the Great Fire of London in 1666 had an even more devastating effect on its infrastructure and housing. The fire burned for five days during the particularly hot summer of 1666, and when it was finally extinguished, nearly 80% of the city's timber and thatch housing had been destroyed, although only six deaths were reported.

The plague and the Great Fire have not been the only misfortunes to befall London through the centuries, and in modern times the city has not been immune to tragedies, from both nature and mankind. In 1953, over 300 people were killed by flooding on the River Thames, and in 2005, 52 people were killed by terrorist attacks in the city. However, all these events have only served to strengthen the resolve and spirit of Londoners, and each setback has seen the city respond with a determined optimism that makes it one of the world's great cities.

History of London

London has had a significant impact on the history of Britain, and some of its historical events, such as Guy Fawkes trying to blow up the English Parliament, have also been absorbed into popular culture.

History timeline

BC
54. Julius Caesar lands in Britain. However, Roman forces do not remain in Britain, but return at a later date.

AD
43. Londinium settled during a second Roman invasion.

61. Boudicca, Queen of the Iceni tribe, attacks the Romans and sacks the city before being defeated.

407. The Romans withdraw from London.

604. The first St. Paul's Cathedral founded by King Ethelbert.

c.750. The Monastery of St. Peter is founded on Thorney Island, which later becomes Westminster Abbey.

886. Alfred the Great makes London the capital of Britain.

1066. William I, Duke of Normandy and descendant of the Vikings, conquers Britain and captures London.

1154. The Plantagenets, originally from France, seize the English throne.

1240. The first parliament sits in Westminster.

1381. Much of London is destroyed by the Peasants' Revolt led by Wat Tyler, as a result of economic hardship.

1534. Henry VIII declares himself head of the Church of England, leading to a break with the Catholic Church.

1536. St James's Palace is built.

1588. William Shakespeare begins working in London.

1605. Guy Fawkes tries to blow up the Houses of Parliament.

1642-9. Civil war between the Cavalier Royalists and the Republican Roundheads. Won by the Roundheads led by Oliver Cromwell, who ordered Charles I's execution.

1660. After 11 years, the monarchy is restored under Charles II.

1664-5. The Great Plague kills one-fifth of the population.

1666. The Great Fire destroys 80% of London's buildings and leads to an extensive rebuilding project.

1675. Sir Christopher Wren (1632–1723) begins work on St. Paul's Cathedral, after it was destroyed in the Great Fire.

1694. The Bank of England is established.

1735. Robert Walpole becomes Britain's first Prime Minister, and takes up residence in 10 Downing Street.

1780. The Gordon Riots. Eight days of rioting take place in London, caused by anti-Catholic feeling and mob rule.

1829. The London Metropolitan Police Force is founded, with policemen nicknamed "peelers" and "bobbies" after its founder, Prime Minister Robert Peel.

1834. Work starts on rebuilding the Houses of Parliament after the old palace of Westminster is destroyed by fire.

1837. Queen Victoria ascends to the throne aged 18.

1851. The Great Exhibition is held in Hyde Park, bringing thousands of visitors to London.

1858. "The Great Stink" in London leads to Joseph Bazalgette creating the city's impressive sewerage tunnel system.

1859. Big Ben is hung in the clock tower of the Houses of Parliament, known as the Bell Tower, but later renamed the Elizabeth Tower after Queen Elizabeth II.

1863. The first section of the Underground railway is built between Paddington and Farringdon Street.

1888. Jack the Ripper strikes in Whitechapel and brings terror to the east end of London.

1894. Tower Bridge is built.

1903. Westminster Cathedral is built.

1932. British Broadcasting Company (BBC) makes its first transmission from Broadcasting House in London.

1939-45. London is heavily bombed, particularly in 1940 and 1941, a period known as the Blitz.

1956. The Clean Air Act introduces smokeless fuel, ending centuries of choking and lethal smogs.

1982. The Thames Barrier is completed, providing flood defences for the city.

1994. The Channel Tunnel is completed, providing options for linking London and Britain to mainland Europe.

2002. The Millennium Bridge reopens after engineering issues causing it to sway were resolved.

2005. On 6 July, London is selected to stage the 2012 Olympic Games. The following day, terrorist attacks in locations across London kill 52 people.

2007. The Eurostar terminal opens at St. Pancras, for trains travelling to Europe through the Channel Tunnel.

2012. London hosts the 27th Olympic Games.

2012. Queen Elizabeth II celebrates her Diamond Jubilee, to mark 60 years on the throne.

2022. Queen Elizabeth II celebrates her Platinum Jubilee, to mark 70 years on the throne.

For a comprehensive look at the history of London, try the excellent book *London, A History of the City*, by Peter Ackroyd, Pan Books.

Arriving in London

The two main methods for travelling to London for a city break are by air and by rail.

Arriving by air

There are four main airports for arriving in London:

- **Heathrow**. The best option for getting into central London is the Heathrow Express train. Trains run every 15 minutes to Paddington station, where the Paddington Tube station can be used to connect with locations across London. The Heathrow Express takes approximately 15 minutes to get to central London.

- **Gatwick**. The Gatwick Express train service travels to Victoria station every 15 minutes, with a journey time of 30 minutes.

- **Stansted**. The Stansted Express train service travels to Liverpool Street station every 30 minutes, with a journey time of 50 minutes.

- **London City**. This can be accessed by the Docklands Light Railway (DLR), or taxi.

Arriving by rail

Several railway stations link with the national railway network, and these are where you may arrive in London if you are travelling by train from other parts of the United Kingdom (UK) (or Europe for St. Pancras International). All of the stations have Tube stations for locations throughout London:

- Euston

- King's Cross

- St. Pancras International (the terminus for the Eurostar service to and from mainland Europe)

- Victoria

- Waterloo

Getting Around

London Underground

Popularly known as the Tube, the London Underground is a must when visiting London, not only as a means of getting around the city, but also just to experience this iconic transport network and its equally iconic map.

One of the first rules about travelling on the Tube is that cash is very definitely not king. It costs considerably more to pay cash for Tube tickets than it does for the other main options: using a contactless credit or debit card, or buying the widely used Oyster

cards and putting the required sum of money on them.

Oyster cards

No self-respecting Londoner travelling on the Tube would be seen without their Oyster card, and anyone on a city break can take advantage of this quick and cost-effective way of travelling around London too. There are

two options for obtaining Oyster cards:

- Buy online, at **oyster.tfl.gov.uk**
Click or tap on the **Get an Oyster card** option and follow the onscreen instructions. You can also top up existing Oyster cards this way, by clicking or tapping on the **Top up or buy season ticket** option and entering your Oyster card number, located in the top right-hand

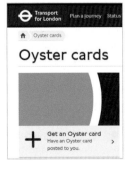

corner on the back of the card. If you are buying a new Oyster card it will be sent to you, so make sure that you order one in good time before you arrive in London.

- Buy at a Tube station. Oyster cards can be bought from the ticket machine at the entrance of all Tube stations. Tap on the **Get new cards** option on the screen to buy a new Oyster card, and enter the amount that you want to put on the card. The ticket machines can also be used to top up the credit on your Oyster card.

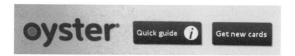

Options for Oyster cards include:

- Pay As You Go, which is used on the Tube;

- Travelcards, which can be used on most forms of London transport; and

- Bus & tram passes, which allow travel on any London buses and trams. More than one option can be added to an Oyster card at the same time.

Once you have obtained your Oyster card, simply swipe it on the barrier terminal when you enter and exit Tube stations (known as touching in and touching out) and the relevant fare will be deducted from the card. There is a cap on the amount you have to pay for a 24-hour period (worth approximately about three separate Tube journeys), and once this has been reached you can make as many more journeys as you like without having to pay any extra.

Contactless

Contactless payments can be used in a similar way to an Oyster card: use the contactless device when you start and finish a journey and you will be charged the same fare as for an Oyster card, and daily journeys are capped in the same way. This can be done with contactless credit or debit cards and also Apple Pay, Google Pay and other contactless payment methods. However, make sure that you use the same method when you touch in and touch out for a journey – i.e. if you touch in with Apple Pay on your iPhone, do the same when you touch out, otherwise the daily cap will not be applied.

Tube tips

Some tips for travelling on the Tube:

- Take a photo of the Tube map (which is available at the entrance to all Tube stations) and use this for reference during your time travelling in London.

- Look at the maps in the Tube stations for each line. Most have two options, so make sure you are travelling in the right direction.

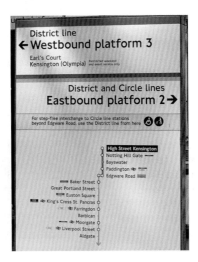

- Most Tube stations have a pre-recorded message on the platforms saying, "Mind the gap, please", or "Mind the gap between the train and the platform". While this can become monotonous, it is good advice because there can be a gap – and also a drop – from the train to the platform, which could cause serious injury.

- Tube trains are announced for the line's final destination, so identify these from the maps in the station to ensure you are going in the right direction.

- Tube trains usually have their line name and their final destination on their front.

- Tube trains enter stations at a thunderous speed and with a thunderous noise, but they will stop in good time at the platform.

- Most Tube stations are serviced by different Tube lines and you can change lines without having to exit the station. However, there can be a considerable walk to get from one line to another.

- Stand on the right-hand side on Tube station escalators, to allow people in a hurry (of which there are many) to walk past on the left-hand side.

- It can be windy walking through the pedestrian tunnels of Tube stations, so hold on to your hat!

Docklands Light Railway (DLR)

The Docklands Light Railway (DLR) is a driverless light metro system that opened in 1987, designed to link areas of London with the Docklands when it was redeveloped, and became a major location for finance and business. DLR trains can be caught from some Tube stations, and Oyster cards can be used on them. From the city centre, the best Tube station to catch the DLR from is Bank. One of the reasons to use the DLR is to visit Greenwich, where you can see the Cutty Sark and the Painted Hall at the Old Royal Naval College.

Cycling

As with many cities around the world, London is trying to promote cycling as much as possible, with an increased number of cycle lanes and cycling initiatives. However, one word of warning: for many Londoners, cycling is a combative pastime and they do not always take kindly to people getting in their way, even if they may not be observing all the rules of the road themselves. Also, cyclists and e-scooters can appear from all angles and, at times, in great swarms, so always keep your eyes out for this. Despite this, cycling is an excellent way to get around the centre of London, particularly as there is now less traffic on the roads due to the congestion charge for cars.

Bicycles can be hired on the streets of London using the red and black Santander Cycles, operated in conjunction with Transport for London. These are racks of bikes that are found in around 800 locations throughout the city, and bikes can be hired from one location and returned to another. Each bike is attached to a docking station, and the nearby payment terminal can be used to access a code for unlocking a bike. Alternatively, the **Santander Cycle** app can be used. Once you have finished with the bike, return it to a docking station. At the time of printing, it costs £2 to hire a Santander Cycle for 30 minutes, and £2 for each additional 30 minutes. This

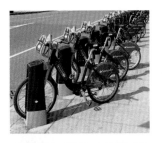

makes them ideal for relatively short journeys, and they are widely used throughout London.

Buses

The network of London buses is extensive, and numerous companies operate bus services, under the overall control of Transport for London. The iconic red London buses can still be seen throughout the city, and Oyster cards can be used for fares, as can contactless cards. Full details about bus services can be found on the Transport for London website, at **tfl.gov.uk/modes/buses/**

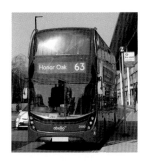

Taxis

Black taxis are a familiar sight on the streets of London. They can be hailed on the street if their yellow light on the roof is showing, or taken from taxi ranks (always go to the taxi at the head of the queue). Private-hire taxis are also available, and Uber operates in the city.

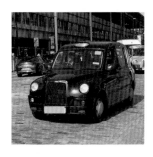

Tour buses

London offers a range of city bus tours, taking in all main sights of the city. Tickets can be bought from kiosks at some of the main tourist sites, such as Trafalgar Square, and you can then hop on and hop off as many times as you like during the day.

On Foot in London

While certain areas of London are excellent for walking around and seeing the sights it is not particularly feasible to walk everywhere, simply because of the size of the city. Instead, break the city down into smaller areas to walk around, and treat these as mini locations. To get to each one, use the Tube as a form of shortcut, and once you have walked around your chosen location, hop on the Tube again.

When planning a day's sightseeing on foot in London, some items to take include:

- A Tube map to plan your shortcuts on the Tube.

- A good pair of walking shoes. The streets of London can be unforgiving on your feet (although they are generally fairly flat, as central London is not a hilly area), so invest in a sturdy pair of walking shoes: your feet will thank you for it.

- An umbrella and a light waterproof jacket that can be folded easily and carried in a bag. Despite what the weather may look like when you first set out, there is always a chance that it could change on an hourly basis!

- Water. It is thirsty work walking around London, particularly in the summer months when the city can become very warm and oppressive. London tap water is perfectly safe to drink and its taste has improved over the years. However, many people favour using bottled water. If you have a backpack with an external sleeve for a water bottle, this will ensure that it is always readily to hand.

Wi-Fi in London

Tourists expect the availability of good-quality Wi-Fi wherever they go these days, and London is well served in this respect. Many establishments provide free Wi-Fi and there is also free Wi-Fi available in the city centre, with the City of London Wi-Fi network. Some Wi-Fi options include:

- **City of London Wi-Fi Network**. This provides free Wi-Fi with speeds of up to 200 megabits per second (Mbps) across the Square Mile of central London. The service is run by the mobile operator O2, and when you connect to the network it will be displayed as **O2 Wi-Fi** on your smartphone. A one-time login is required to connect to the service, using an email address and password.

- **The Cloud Wi-Fi**. This is a free Wi-Fi service, operated by Sky, available in thousands of hotspots, such as Caffè Nero, Pizza Express, Pret, Wagamama, and many public areas such as shopping centres. Select the **_The Cloud Wi-Fi** option and connect using a one-time login.

- **McDonald's**. The fast-food giant offers a free Wi-Fi service for its customers. Select the **McDonald's Wi-Fi** option and connect using a one-time login.

- **Starbucks**. The ubiquitous Starbucks also offers free Wi-Fi to its customers. Select the **Starbucks Wi-Fi** option and connect using a one-time login.

- Some public buildings in London offer free Wi-Fi, which requires a one-time login to gain access. These include the Royal Albert Hall, the National Gallery, and the British Museum.

- **Station Wi-Fi**. If you are desperate to use Wi-Fi on the Tube, this can now be done with Station Wi-Fi in over 260 Tube station locations. The service is operated by Virgin Media and is free for its customers and also customers of some other mobile networks. Alternatively, a Wi-Fi pass can be bought from Virgin Media (**wifipass.virginmedia.com**), and this can be used for Station Wi-Fi.

Weather

Even though London has a historical reputation for thick smog in the city (known as a "pea-souper"), which was caused by windless, cold weather combined with air pollutants such as those caused by burning coal, its weather is generally no more or less newsworthy than any other part of the UK.

The problem with fog and smog in London had been a major issue in the city for centuries, and the most notorious London pea-souper occurred in 1952, when a four-day smog caused major disruption in the city and contributed directly to at least 4,000 deaths, with many more falling ill. This led to the Clean Air Act 1956, which restricted the burning of coal and established smoke-free areas in the city.

Thankfully, the days of extreme smog have gone now, and with road traffic also reducing, the air quality of London is nowhere near pea-souper levels. However, there are still issues with air pollution, and on hot days there can be warnings regarding the air quality. Look out for signs around the city alerting you to any issues with the levels of air pollution. There is also a website where you can check the air quality in various locations around London, which is particularly useful for anyone with breathing issues. The website is London Air, at **www.londonair.org.uk**

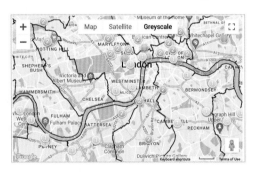

In the summer, London can get quite hot and humid, but for much of the year it is prone to the classic British weather conditions of "changeable".

Food and Drink

London is very well served by restaurants that cater for every taste and budget, and you can dine on some of the finest cuisine from all corners of the globe. In addition to this there is a huge range of pubs and restaurants that serve up British culinary classics, including:

- **Fish and chips with mushy peas**. This staple of British cuisine is frequently the first thing on the menu in pubs and many restaurants. The accompaniment of mushy peas is something of an acquired taste (basically, peas cooked into a pulp and flavoured with mint or lemon, or both) but other vegetable options are also available.

- **Sunday roast**. A quintessentially British creation, the Sunday roast can be found in many pubs and restaurants on a Sunday, frequently in buffet form.

- **Bangers and mash**. Sausages and mashed potatoes is another great British staple, served with generous amounts of gravy.

- **Pie and mash**. Steak pie is traditionally the pie of choice for this dish, but these days London pubs and restaurants have a range of choices, including vegetarian and vegan options.

- **High tea**. Now no longer the preserve of the upper classes, high tea – delicate sandwiches, fine cakes and a pot of tea – is served in an array of establishments in the city.

- **Eton mess**. This classic dessert featuring meringue, whipped cream and fresh fruit (usually strawberries or other summer fruits) was created at Eton College, the famous English public school located in Windsor, just to the west of greater London. It is now a firm favourite on menus throughout the capital.

Public Toilets

The Covid-19 pandemic has played havoc with large numbers of public toilets in London. At the time of printing, many of them remain closed, and it is unclear for how long this will remain the case. However, there are still a number of options for accessing public toilets throughout London, with many of them being free:

- National Rail stations. All of the main railway stations in London have free public toilets that can be used even if you are not travelling from the station. Some of these include King's Cross, Paddington, St. Pancras International, Victoria and Waterloo.

- The City of London's Community Toilet Scheme provides access to toilet facilities within participating establishments. These include shops, restaurants, pubs and cafés, and they will usually display a blue sign in their window. Where possible, participating establishments will offer free toilet facilities, disabled access, and baby-changing facilities, without a requirement to buy anything.

- Some public buildings, such as museums and art galleries, have free public toilets. Although many of them have free entry, you may still require a ticket, and have to queue for entry to the establishment.

- Many parks and green spaces have public toilets, but a large number have been closed since the Covid-19 pandemic, and some also require payment for use.

- Some Tube stations in the centre of London have toilets, but they usually require payment for use. These include Baker Street, Blackfriars, Charing Cross, Green Park, Marylebone, Piccadilly, and Westminster.

- If all else fails, buy something in a café, bar or pub and use the toilets there.

3 Smartphone Photography

When you are on a city break, there are a lot more exciting things to do than worry about the settings on your smartphone camera or how you are going to capture the best photos with it. However, if you are armed with a few simple tips and tricks you will feel that you can concentrate on the photos you are going to take, rather than the smartphone camera itself.

This chapter covers some points for using your smartphone camera so that you can channel all of your attention on the subjects. This includes: mastering your camera's settings so that it is always ready for optimum use; changing the orientation to capture two different photos from the same spot; using filters for artistic effects; ensuring that you always have the correct focus and exposure for your photos; capturing several photos for the same subject, to ensure you have the best lighting; using a grid for composing elements in your photos; and ensuring that your smartphone camera is kept in the best condition possible.

Using Camera Settings

On traditional digital cameras, the various settings can be accessed from buttons or controls on the body of the camera and also from a menu that is usually viewed on the screen on the back of the camera. However, camera phones do not have this functionality on the body of the smartphone. Instead, settings can be accessed from the screen of the **Camera** app and also within the smartphone's **Settings** app. This is where a range of settings can be applied for the smartphone, including those relating to the camera. To access camera settings on a smartphone:

1 Tap on the **Settings** app

2 Tap on the **Camera** option within the **Settings** app

3 A range of settings can be applied for the camera, depending on the make and model of smartphone (other settings, such as flash and self-timer, can be accessed from the **Camera** app)

Orientation

Most of the photos in the book have been taken in Portrait mode, as it is the most effective orientation for the page format. However, one of the quickest and easiest ways to change the composition of a scene is also one of the most effective: simply turn the smartphone 90 degrees. This changes the orientation from Portrait to Landscape, or vice versa. Since it only takes a few seconds to do, it is worth considering this for most photos that you take:

- Portrait photos give more emphasis to the vertical aspect of a scene.

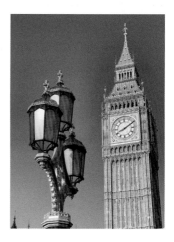

- Turn the smartphone 90 degrees to Landscape orientation, which gives more emphasis to the horizontal aspect of a scene and creates a different perspective.

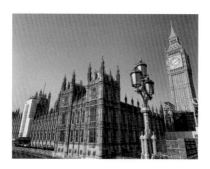

Focusing and Exposure

Smartphone cameras are very adept at focusing on the scene in front of them and measuring the required exposure, known as Auto Focus (AF) and Auto Exposure (AE). However, by default they try to do this over as much of the scene as possible. On most occasions this is what is desired, but there may be times when you want to have the camera take these readings from one specific point. If this is done, the smartphone camera will still try to get the correct readings to have as much of the rest of the photo in focus as possible.

To select a specific AF and AE area in a photo:

1 Open the **Camera** app and compose a scene

2 Press and hold on the screen on an area that you want to be the main focal and exposure area

3 A coloured square appears over the selected area

4 Keep holding on the screen until the **AE/AF Lock** button appears at the top of the screen. This indicates that the focal point and exposure have been set where you specified, and it will remain there once you remove your finger from the screen and move the camera

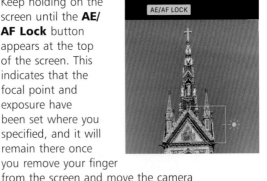

Working with Filters

Filters are artistic effects for digital photos that can give them a significantly different – and frequently artistic – appearance. Filters can be added when photos are edited using a photo-editing app, and they can also be applied when a photo is taken with a smartphone camera. If this is the case, the original photo will have a filter applied to it: if you want to capture a realistic version of a scene, take a photo of it without a filter first. Another photo using a filter can then be taken afterwards. To apply a filter when a photo is being taken:

1 Open the smartphone's **Camera** app

2 Tap on the **Filter** button

3 Tap on one of the filter options to apply it to a photo before it is taken

DRAMATIC COOL

4 Capture the photo. The filter will be applied and will stay selected until another filter is selected or the **Filter** button is turned **Off**

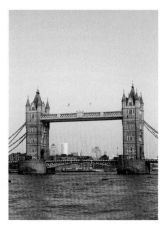

Getting on the Grid

Composition is one of the key elements of good photography; i.e. where subjects are placed in a photo. Generally, the main subject appears in the centre of a photo, but there are good artistic reasons to move the main subject to other areas of the photo. This can be done visually when composing a photo with the smartphone's **Camera** app. However, it is possible to make this process slightly easier by displaying a grid over the scene that is being viewed. This is a 3 x 3 grid that produces nine segments: the main subject can then be positioned within any segment (or at the intersection point between segments – see the next page) to create a more artistic composition. The grid can be displayed or hidden within the camera settings:

1 Access the camera settings as shown on page 44

2 Tap on the **Grid** option so that it is **On**

Grid	

3 When the **Camera** app is opened, the grid is superimposed over the scene being viewed (the grid does not appear in the final photo)

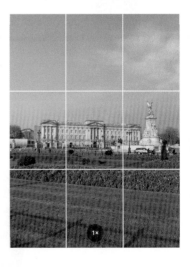

Rule of Thirds

The Rule of Thirds is a photographic composition technique that can be used to position a main subject within any of the nine segments that are created by the 3 x 3 grid, or at any of the intersection points. If you have a particularly appealing scene in front of you it is worth experimenting by taking several photos, positioning each one in a different location according to the Rule of Thirds. This can create different end results from the same location:

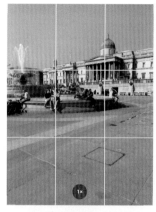

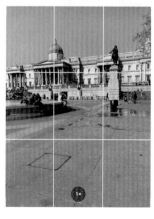

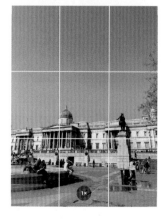

Bracketing and HDR

There are some photographic scenes that we can capture numerous times; e.g. those close to our home. However, at times there will also be locations and photographic opportunities that may be a one-off. In cases like this, it is important to try to get the best shots possible in case you do not get the chance again. One way to do this is to take each shot at different exposure settings, known as "bracketing". This can be done manually by changing the exposure for different shots by pressing on the screen at different points to lock the exposure, as shown on page 46.

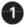 Press and hold on the screen to select the exposure for a specific area of a scene, and take a photo. Press and hold at another point to alter the exposure of the scene, and take another photo. Repeat this as often as required

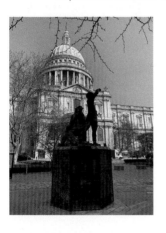 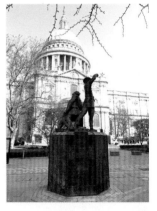

Also, some smartphone cameras can bracket photos automatically using a technique known as HDR (High Dynamic Range). This takes at least three photos at different exposures and then combines them to create one photo with the ideal exposure. HDR mode can usually be accessed from a button within the smartphone's **Camera** app, or within the **Settings** app.

Zooming In and Out

Smartphone cameras have a zoom function so that you can make subjects appear larger on the camera's screen. However, unlike traditional cameras that use an optical zoom by changing the distance between the camera's internal lenses, digital zoom is the same as cropping a photo or zooming in on it using a photo-editing app. Digital zoom works by increasing the size of the pixels on the screen, and produces an inferior quality compared with using optical zoom. It is therefore important that zooming is not overused on smartphone cameras: the greater the amount of zoom, the greater the reduction of image quality (and the same effect can be achieved by cropping a non-zoomed photo). However, it can still be useful to use a certain degree of zoom, and there are two ways to do this:

1 Swipe inwards with thumb and forefinger to zoom out on a scene with the **Camera** app

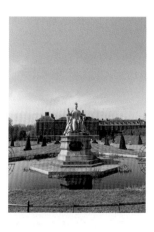

2 Swipe outwards with thumb and forefinger to zoom in on a scene with the **Camera** app

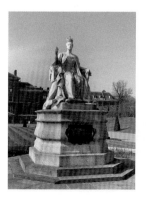

Getting the Right Light

Timing

One way to ensure that you get the best photos possible is to try to make sure that you get the best lighting for your subjects that you can. In a lot of cases, this can be achieved by being at the required location at a time when the sun is at the best position for the photo (if it is shining). For example, the two photos below are both of Buckingham Palace, taken from the same location but at different times of day. The first photo was taken in the afternoon when the sun was behind the subject, meaning it appears in shadow. However, the second photo was taken early in the morning with the sun on the subject, and the difference is dramatic. Take some time to work out where the sun is going to be before you set off to take photos on a city break, although the optimum time of day is listed with the top sights and hidden photos in the book.

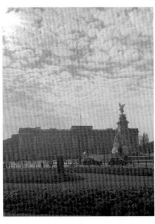

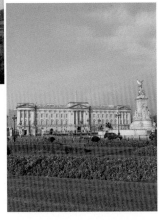

...cont'd

Positioning

Equally as important as the time of day for taking photos can be where you position yourself. This can involve moving a few metres or, in some cases, finding a different perspective altogether. For example, the two photos below are both of the Royal Albert Hall. However, the first one was taken from Hyde Park, with the sun behind the building, leaving it in shadow. The second photo was taken after walking around the building to ensure the sun was shining on it. As with the photos on the previous page, a small amount of effort has transformed the photo.

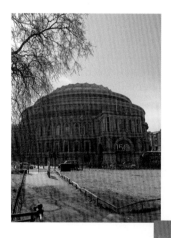

The Golden Hour

For the best photographs, the ideal natural lighting conditions usually occur approximately one hour after sunrise and one hour before sunset. In photographic terminology this is known as the Golden Hour.

The reason that the Golden Hour is so good for photography is because of the angle at which the light hits its subjects, and because at these times it produces a deep glow rather than the harsh glare of the midday sun. The morning and evening Golden Hours produce slightly different effects: the morning sun has a soft golden effect, while the evening sun tends to have a stronger orange glow with a bit more depth to it.

The other thing to be aware of about the Golden Hour is that it is short. This means that you will not have a lot of time to move from location to location. It is best to pick a subject that you want to capture and then concentrate on a few top-quality shots.

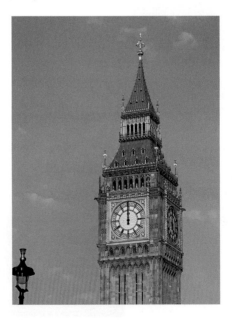

Going Black and White

Black and white can create very artistic photos, and can be used to develop a style that stands out against the majority of colour photos that are produced. Black and white photos can be created when a photo is taken with a smartphone camera, usually by using the appropriate filter, or in a photo-editing app once a photo has been taken. If possible, create photos in black and white when a photo is taken, as well as colour versions.

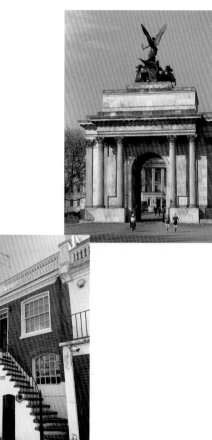

Basic Maintenance

Unlike traditional cameras, smartphone cameras generally do not have as many accessible moving parts. This means that they are less susceptible to damage through everyday irritants such as dirt and dust. However, there are still a few steps that can be followed to ensure that your smartphone's camera remains in the best condition:

- **Keep the lens clean**. If specks of dust or dirt are on the lens, these could show up in photos. Use a soft, lint-free cloth (similar to those used to clean spectacles) to clean the lens, particularly at times when you are taking an important photo.

- **Regularly inspect the lens for any physical damage such as scratches**. If the lens is scratched, this will impact all of your photos.

- **Use a phone cover that has a raised edge to protect the camera**. If the phone is dropped, the cover's edge should hopefully save the camera from any damage.

- **Avoid extremes of heat or cold**. These could affect the overall operation of the smartphone and therefore impact on the efficiency of the camera.

4 London Top Sights

Many of the top tourist sights in London, including Buckingham Palace, Big Ben, and St. Paul's Cathedral, are known around the world and are easily recognisable. This chapter shows you locations to capture photos of these iconic sights, without having to spend precious hours of your city break trying to track down where to take photos from. The photo locations all include exact references using the **what3words** *app.*

In addition to the most famous sights, central London is also full of top sights that are well worth a visit, including: the Royal Albert Hall, Tower Bridge, Westminster Abbey, Shakespeare's Globe, St. Pancras railway station, and many more, all covered in this chapter.

If you cover all – or most – of the photo sights in this chapter then you will be well on your way to discovering the character and history of London, one of the most exciting and vibrant cities in the world.

Buckingham Palace

Photo spot: Foot of The Mall.
what3words ref: bless.fever.deputy

Direction: Facing west 270°W

Camera zoom: x1

Best time of day: Early morning, with the sun to the left-hand side (it's worth getting up early to get this photo, as the sun moves away quickly).

Additional shot: Move to the right to capture a shot of Buckingham Palace and the Victoria Memorial.

 Selfie spot: Stand to the left or right at the photo spot to get as much of Buckingham Palace in the selfie as possible.

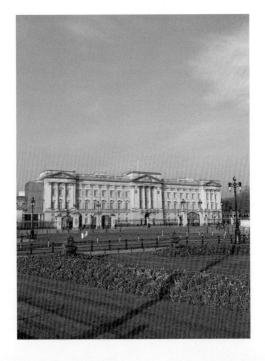

...cont'd

About this photo

Nearest Tube station: St. James's Park. Exit the Tube station into Petty France at **gosh.bonds.keeps**.

Getting there: Continue west along Petty France for 280 metres, turning right up Buckingham Gate at **bowls.miss.cuts**, and continue for 230 metres. Cross Birdcage Walk into Spur Road at **hoot.loss.engage**. Walk north along Spur Road for approximately 180 metres to get to the photo spot.

Photo fact: Although Buckingham Palace is synonymous with the British royal family, it has only been a royal residence for a relatively short time in the context of British history. There have been several buildings on the site of the current Buckingham Palace, including one built by the Duke of Buckingham at the start of the 18th century, from where it gets its name (it was called Buckingham House at the time). In 1762 George III acquired the site and developed it as a private home for the royal family. In 1820 George IV acceded to the throne and commissioned John Nash (1752-1835) to expand the existing house into a palace, which resulted in Buckingham Palace as we know it today. In 1837 Queen Victoria was the first sovereign to use Buckingham Palace as the official seat of court, in effect establishing it as an official royal residence. Victoria developed the palace still further as she considered it too small, and it has remained the monarch's main residence in London. Tours can be taken to view the State Rooms in the palace.

Nearby food and drink: Bon Gusto on Buckingham Gate, at **expose.issue.common**, offers good-value Italian food for breakfast, lunch and dinner.

Nearby attractions: Green Park, to the right of Buckingham Palace in the photo, is a green space that offers some relief from the crowds that can congregate at the palace.

Big Ben Westminster Bridge

Photo spot: On Westminster Bridge.
what3words ref: popped.known.fame

Direction: Facing south 175°S

Camera zoom: x2.2

Best time of day: Early morning, with the sun behind.

Additional shot: The Houses of Parliament can be captured to the left of Big Ben from the photo spot.

Selfie spot: Take care capturing selfies of Big Ben from Westminster Bridge as it can be very busy with tourists and locals trying to get to work. Try not to get in anyone's way.

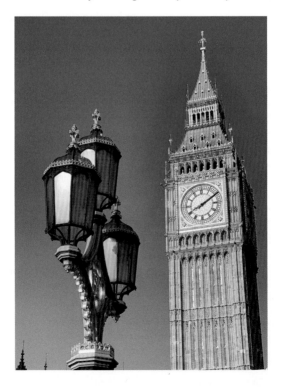

...cont'd

About this photo

Nearest Tube station: Westminster. Exit the Tube station onto Bridge Street at **market.poem.about**.

Getting there: Turn left along Bridge Street and cross the road. Continue 100 metres east to the photo spot, on Westminster Bridge.

Photo fact: Big Ben is an iconic emblem of London that is arguably the most famous sight in the city. Big Ben is the bell that is situated in the impressive bell tower, originally known as the Clock Tower, but renamed the Elizabeth Tower in 2012 to mark the Diamond Jubilee of Queen Elizabeth II. Big Ben and the Elizabeth Tower are part of the adjacent Houses of Parliament. The clock tower was commissioned in 1840, along with a new parliament building, after the previous one was destroyed by fire. Construction of the clock tower began in 1843, and in 1846 a competition was launched for someone to build the clock. Due to the logistics of creating such a large clock that could also retain its accuracy, it took seven years until the final design was accepted. The clock mechanism was completed in 1854, with the first bell created two years later. This was the first "Big Ben", and it had to be replaced in 1858 due to a crack in the original. Both the clock and the bell became operational in 1859, and they have continued to function over the years, despite various pauses for mechanical failures and the outbreak of wars. In 2017 a major renovation project was undertaken to protect the Elizabeth Tower and Big Ben for generations to come, the majority of which has now been completed.

Nearby food and drink: The St. Stephen's Tavern on nearby Bridge Street, at **rift.relate.highs**, is a local pub steeped in the history of the Houses of Parliament.

Nearby attractions: On Westminster Bridge there are memorials to the people killed in the terrorist attack here in 2017 (see pages 30 and 186).

Big Ben Parliament Square

Photo spot: Parliament Square, south side.
what3words ref: league.forget.just

Direction: Facing east 82°E

Camera zoom: x1

Best time of day: Afternoon, with the sun behind.

Additional shot: Use the panorama setting on your smartphone camera to capture the whole of Parliament Square and its surroundings.

Selfie spot: If you are so inclined, you may be able to capture a selfie with Members of Parliament as they leave the House of Commons; see the next page.

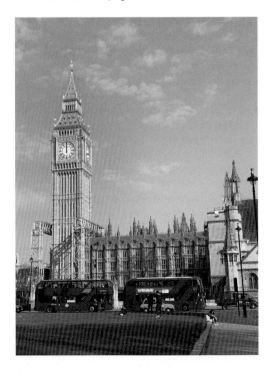

...cont'd

About this photo

Nearest Tube station: Westminster. Exit the Tube station onto Bridge Street at **market.poem.about**.

Getting there: Cross Bridge Street and turn right, heading west. At the junction of Bridge Street and Parliament Square, at **oppose.idea.wiped**, turn left and walk around Parliament Square to reach the photo spot.

Photo fact: Big Ben and the Elizabeth Tower make an effective photo from almost any angle, but they are particularly attractive with some of the green areas of Parliament Square and Parliament Square Garden in the foreground. If you are patient, you may also get the iconic red London buses in the shot too. Due to its proximity to the Houses of Parliament, there are frequent demonstrations and protests held in Parliament Square, all trying to catch the attention of nearby Members of Parliament. They can sometimes be seen leaving the Houses of Parliament, via the heavily guarded exit at the east side of the square, at **salads.mimic.exit**. The design of Parliament Square dates back to 1868, with the intention to open up the area around the Houses of Parliament to make it a more relaxing and appealing environment. The square was renovated in 1948, following damage during World War II. There are also 12 statues of notable people through history around the perimeter of Parliament Square. The square is patrolled by Heritage Wardens who assist with queries and enforce any local bylaws relating to the square.

Nearby food and drink: Parliament Square is an excellent location for a relaxing picnic in the heart of London, but it is forbidden to feed the pigeons that frequent the square!

Nearby attractions: Westminster Abbey lies to the south of Parliament Square; see pages 66-67 for details.

Houses of Parliament

Photo spot: Albert Embankment Path.
what3words ref: tides.rides.closes

Direction: Facing northwest 322°NW

Camera zoom: x1

Best time of day: Morning, with the sun behind.

Additional shot: A wider shot (in Landscape mode) can also be taken from Albert Embankment Path; however, some of the Houses of Parliament is covered during to building work (see the next page), and will be for several years.

 Selfie spot: Position yourself to the left of the photo to capture a selfie with the Houses of Parliament and also Big Ben.

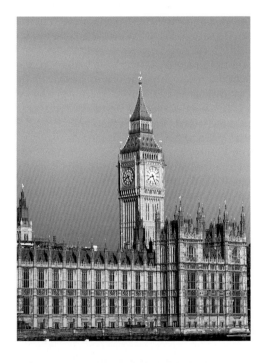

...cont'd

About this photo

Nearest Tube station: Westminster. Exit the Tube station onto Great George Street at **market.poem.about**.

Getting there: From the photo spot for Big Ben from Westminster Bridge (see pages 60-61), walk to the eastern end of Westminster Bridge and turn right onto Albert Embankment Path, at **trucks.moved.scan**. Walk a further 150 metres along Albert Embankment Path to the photo spot.

Photo fact: Known officially as the Palace of Westminster, the building contains the House of Commons and the House of Lords, the two legislative chambers of the UK parliament, and known collectively as the Houses of Parliament (including Westminster Hall). The current Palace of Westminster was built after the existing one was destroyed by fire in 1834. Following a competition for its design, won by Charles Barry (1795-1860) with his Gothic vision, the first stone was laid in 1840. As with many public works projects, there were considerable overruns on both timescale and cost, but the House of Lords was able to sit in the new building in 1847 and the House of Commons in 1852. The Palace of Westminster suffered considerable damage from bombings during the Blitz in 1940 and 1941, including the destruction of the Commons Chamber (House of Commons). Renovation work followed and was completed in 1950. However, the Palace of Westminster is now showing its age, and in 2018 it was decided that it should undergo a complete and extensive renovation and refurbishment. This is planned to start in 2025 and to last for up to six years.

Nearby food and drink: Okan South Bank, at **turned.range.verbs**, offers excellent-quality authentic Japanese food.

Nearby attractions: Along the Albert Embankment Path stretches a wall that serves as a memorial to everyone in the UK who died as a result of the Covid pandemic (see page 166).

Westminster Abbey

Photo spot: Broad Sanctuary, Westminster.
what3words ref: stack.suffer.raves

Direction: Facing east 87°E

Camera zoom: x1

Best time of day: Late afternoon, with the sun behind.

Additional shot: The front of Westminster Abbey is adorned with dozens of statues that make good close-up photos; see page 108 for details.

Selfie spot: Capture a selfie with the doors of Westminster Abbey, where numerous kings and queens have passed over the centuries.

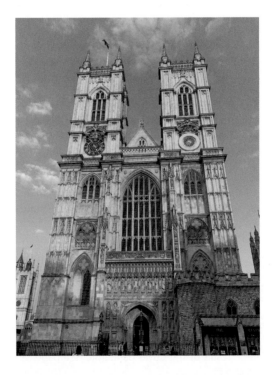

...cont'd

About this photo

Nearest Tube station: Westminster. Exit the Tube station onto Bridge Street at **market.poem.about**.

Getting there: Follow the directions for Big Ben Parliament Square on pages 62-63 and continue west along Broad Sanctuary for 175 metres to get to the photo spot.

Photo fact: Although Westminster Abbey is one of the most iconic buildings in the country, it can sometimes be overlooked by some of its near-neighbours, including Big Ben and the Houses of Parliament. However, located on the south side of Parliament Square, the impressive Westminster Abbey is well worth its reputation as a must-see sight. It is a royal church, a World Heritage Site, and has overseen over 1,000 years of English and British history. The abbey was founded by Benedictine monks in AD 960, and since 1066 it has served as the location of coronations for English and British monarchs. The current Westminster Abbey was commissioned by Henry III in the middle of the 13th century, and it soon become the desired location for monarchs for not only their coronations but also their final resting place. Several royal weddings have been held in Westminster Abbey and a number of famous people through history have been buried there, including Sir Isaac Newton, Charles Darwin, Charles Dickens, George Frideric Handel, and Stephen Hawking. Westminster Abbey is also the site of the sobering Grave of the Unknown Warrior, commemorating all the victims of World War I who were never identified.

Nearby food and drink: The Cellarium Cafe & Terrace is located within Westminster Abbey, providing an airy location for breakfast, lunch and afternoon tea.

Nearby attractions: Part of Westminster Abbey is Poets' Corner, containing the graves or memorials of over 100 major literary figures through history.

The Mall

Photo spot: The Mall, next to St. James's Park.
what3words ref: palace.rival.flames

Direction: Facing southwest 245°SW

Camera zoom: x3

Best time of day: Morning, with the sun behind.

Additional shot: The tree-lined pavements on either side of the road can create an artistic photo, particularly when the trees are in bloom.

 Selfie spot: Since The Mall has limited traffic, it is possible to capture a selfie while standing on the road itself, but always make sure that it is safe to do so first.

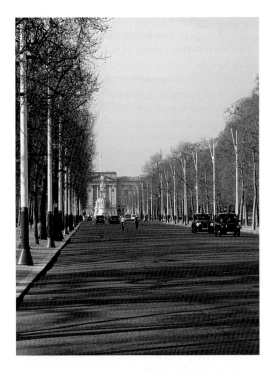

...cont'd

About this photo

Nearest Tube station: St. James's Park. See directions for getting to the photo spot for Buckingham Palace on page 59.

Getting there: From the photo spot for Buckingham Palace, continue 500 metres northeast along The Mall to the photo spot to capture a photo of The Mall with Buckingham Palace in the background.

Photo fact: The Mall is the road that connects Buckingham Palace and Trafalgar Square. With trees lining either side, the width of The Mall and its setting with Buckingham Palace at one end make it ideal for ceremonial events and parades. For events such as royal weddings, The Mall is thronged with people, with everyone trying to catch a glimpse of the royal family on the balcony of Buckingham Palace. Originally created by Charles II in 1662, The Mall has always been home to grand houses, designed by some of the finest architects of each generation. It also boasts numerous statues and monuments, including Admiralty Arch (see pages 70-71) near to Trafalgar Square, and the Victoria Memorial outside Buckingham Palace. During Queen Victoria's reign, The Mall took on even greater prominence and was used for royal processions and for parades for state visits of foreign dignitaries. These were extravagant events, full of flags, crowds and pageantry, and this continues to be the case today. The Mall is closed to traffic on Sundays, public holidays and for state events, although most traffic is restricted from The Mall in general.

Nearby food and drink: Although there are limited food and drink options near The Mall, the Great British Restaurant, at **joke.clip.clips**, offers a modern twist on some classic dishes.

Nearby attractions: St. James's Park, running down the left of the photo spot, is somewhere that should not be overlooked, as it is a beautiful park in the heart of the city (see Chapter 6).

Admiralty Arch

Photo spot: The Mall.
what3words ref: skin.stop.heap

Direction: Facing northeast 35°NE

Camera zoom: x1

Best time of day: Afternoon, with the sun to the left.

Additional shot: Capture shots of the outer wings so that the red and white barriers are not visible.

 Selfie spot: Don't be put off by the police usually in the vicinity of Admiralty Arch; they won't mind you taking selfies with the arch behind, as long as you don't try to go inside it.

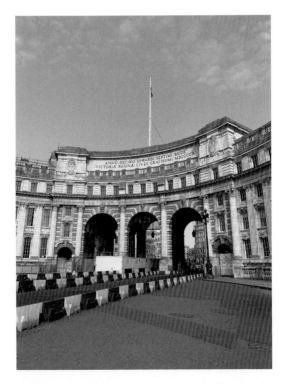

...cont'd

About this photo

Nearest Tube station: Charing Cross. Exit the Tube station to the left, onto Strand at **melon.copy.pull**.

Getting there: Head southwest along Strand for approximately 275 metres to reach the photo spot, passing Trafalgar Square on the right-hand side and joining The Mall across the roundabout (crossing Northumberland Avenue and Whitehall), at **admiral.carbon.spin**.

Photo fact: Built in memory of Queen Victoria, the grand and impressive Admiralty Arch is a suitable memorial for the country's longest-reigning monarch at the time (later surpassed by Queen Elizabeth II). It was part of a larger memorial project that also included the Victoria Monument and the Memorial Gardens, outside Buckingham Palace. Admiralty Arch was funded by public donations, commissioned by Edward VII and designed by Sir Aston Webb (1849-1930). It consists of three large arches with residential rooms on either side. Over the years these have been occupied by a range of prominent people and organisations, including the First Sea Lord, who is the head of the Royal Navy, and the Cabinet Office, a branch of the UK government. In 2012 Admiralty Arch was sold to a property company that intends to transform it into one of the most exclusive hotels in London. The Latin inscription at the top of Admiralty Arch translates as, "In the tenth year of King Edward VII, to Queen Victoria, from most grateful citizens, 1910".

Nearby food and drink: There are limited food and drink options at Admiralty Arch, although there are numerous options around nearby Trafalgar Square.

Nearby attractions: To the right of the photo spot is the back of the Old Admiralty Building, which was historically used to oversee the running of the Royal Navy and has been the site of many of the country's most important ceremonial events.

Trafalgar Square

Photo spot: Trafalgar Square, off Strand.
what3words ref: friend.strict.behave

Direction: Facing southeast 124°SE

Camera zoom: x1

Best time of day: Afternoon, with the sun to the right.

Additional shot: The Fourth Plinth at **shirts.civil.noon** contains different eye-catching examples of modern art.

Selfie spot: Try to capture a selfie with the lions at the foot of Nelson's Column.

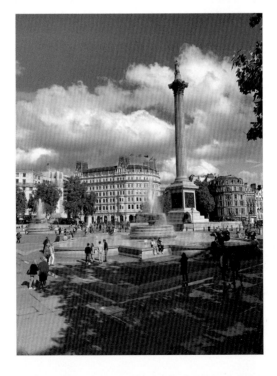

...cont'd

About this photo

Nearest Tube station: Charing Cross. Exit the Tube station onto Strand at **melon.copy.pull**.

Getting there: Walk southwest along Strand for 100 metres, until you reach Trafalgar Square on the right-hand side at **swear.clown.secret**. Walk through Trafalgar Square to the northwest corner to get to the photo spot.

Photo fact: The Battle of Trafalgar in 1805 is considered to be one of the greatest British naval victories, and so it is perhaps fitting that there is now a whole square dedicated to it. The centrepiece of the square is Nelson's Column, in memory of Lord Horatio Nelson who led the victory at the Battle of Trafalgar, but died in the process (see pages 74-75). Trafalgar Square as it is today was designed by one of the leading architects of the day, John Nash, and it was officially opened in 1844. Some of the features of Trafalgar Square include the four bronze lions that sit at the bottom of Nelson's Column, protecting the monument, and the four plinths in the corners of the square, three of which consist of statues, and one (the Fourth Plinth) that displays a rotating range of contemporary artwork. Trafalgar Square has long had a democratic tradition of allowing festivals, religious celebrations and peaceful demonstrations, and this continues to this day, with most weekends being used for this purpose by one group or another, activities that are sanctioned by the Mayor of London.

Nearby food and drink: There are no food or drink options in Trafalgar Square itself, although there are numerous outlets around its perimeter.

Nearby attractions: Opposite Nelson's Column, on the roundabout at the top of The Mall, at **buzz.roof.spends**, is an equestrian statue of Charles I (1622-49), who reigned during the English Civil War (1642-52); see pages 74-75.

Nelson's Column

Photo spot: Trafalgar Square.
what3words ref: tells.claims.movies

Direction: Facing northwest 323°NW

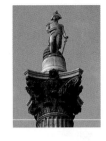

Camera zoom: x1

Best time of day: Afternoon, with the sun behind.

Additional shot: Zoom in as much as possible on the statue of Nelson at the top of the column.

Selfie spot: Position yourself so that you can capture a selfie that includes some of the column and also the statue of Nelson.

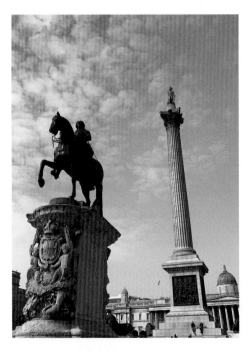

...cont'd

About this photo

Nearest Tube station: Charing Cross. Exit the Tube station onto Strand at **melon.copy.pull**.

Getting there: Walk southwest along Strand for 100 metres, until you reach Trafalgar Square on the right-hand side at **swear.clown.secret**. Walk through Trafalgar Square to get to the photo spot.

Photo fact: Arguably England's greatest naval figure, Lord Horatio Nelson's column dominates Trafalgar Square, named after his most famous naval victory, the Battle of Trafalgar against the Franco-Spanish fleet in 1805, and where he was killed after his greatest victory. Nelson joined the Royal Navy at the age of 12 and quickly worked his way through the ranks to become Vice Admiral shortly before the Battle of Trafalgar. Nelson was a very proactive commander and he sometimes took risks to achieve his numerous naval victories. He famously turned a blind eye to his telescope when ordered to retreat during an assault on Copenhagen, leading to an eventual victory. His final battle, at Cape Trafalgar, resulted in one of the great naval quotes, when Nelson sent out a signal saying, "England expects that every man will do his duty". However, the battle proved his undoing when he was shot by a French sniper, but Nelson's legacy in the history of England is fully assured. The statue to the left of Nelson's Column in the main photo on the previous page is of Charles I, one of the most controversial figures in British history, who fought in the English Civil War and was executed for high treason in 1649.

Nearby food and drink: As for Trafalgar Square on page 73.

Nearby attractions: The photo spot is at the head of The Mall and Admiralty Arch; see pages 70-71 for details.

National Gallery

Photo spot: Trafalgar Square.
what3words ref: hurls.square.backs

Direction: Facing northwest 318°NW

Camera zoom: x2.5

Best time of day: Afternoon, with the sun behind.

Additional shot: Move slightly to the left of the photo spot
to capture a photo with the gallery and the fountain.

Selfie spot: Numerous selfies can be taken
with the National Gallery, and the fountains and
statues in front of it.

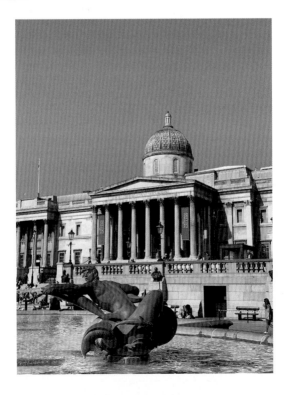

...cont'd

About this photo

Nearest Tube station: Charing Cross. Exit the Tube station onto Strand at **melon.copy.pull**.

Getting there: Walk southwest along Strand for 100 metres, until you reach Trafalgar Square on the right-hand side at **swear.clown.secret**. Walk through Trafalgar Square to get to the photo spot.

Photo fact: For any art lover, a visit to the National Gallery is a must, and it's free. Ranging from the 13th century up to the 20th century, the National Gallery has some of the world's most famous paintings, from artists including Leonardo da Vinci, van Eyck, Raphael, Titian, Holbein, Vermeer, Caravaggio, Turner, Monet, and Van Gogh. The main exhibition rooms are on Level 2 of the gallery, and it is recommended that three to four hours are taken to view all of the exhibits. Although entry is free to the main exhibits, it is wise to book tickets as you may have to queue if you do not have booked tickets. Tickets can be booked online at **nationalgallery.org.uk** In addition to the main exhibits, there are also numerous additional exhibitions at the National Gallery, and these usually have an entry fee. These are also shown on the National Gallery website, which includes a range of art-related information, such as methods of restoring paintings and how exhibits are curated.

Nearby food and drink: There are three dining options at the National Gallery: the Ochre restaurant, to experience the "art of eating"; the more casual Muriel's Kitchen; and Espresso Bar for an invigorating cup of coffee or similar.

Nearby attractions: Relatively near to the National Gallery is another exceptional collection of art, at the Courtauld Gallery, at **twigs.avoid. funds**. This can be reached by walking northeast along Strand from Trafalgar Square.

Marble Arch

Photo spot: Cumberland Gate, next to Hyde Park.
what3words ref: cried.tapes.media

Direction: Facing northwest 313°NW

Camera zoom: x1.2

Best time of day: Late morning/afternoon, with the sun to the left.

Additional shot: Although not as decorative as originally intended (see the next page), the panels on Marble Arch are still worthy of close-up photos.

Selfie spot: Position yourself in front of Marble Arch to capture a selfie in the middle of the three arches.

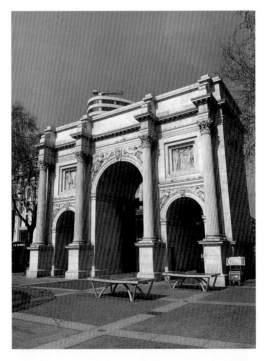

...cont'd

About this photo

Nearest Tube station: Marble Arch. Exit the Tube station onto Oxford Street at **clock.press.senses**.

Getting there: Cross Oxford Street and walk around Marble Arch to the photo spot, next to Cumberland Gate.

Photo fact: Although Marble Arch is an impressive monument, made from Carrara marble, it is not as grand as the original plans intended it to be. Designed to celebrate the British victory in the Napoleonic Wars (1803-1815) against the French, Marble Arch was originally located near to Buckingham Palace, to add to its grandeur. It was designed by one of the most prominent architects of the day, John Nash. Commissioned by George IV, Nash's initial design was an elaborate affair, with numerous decorative panels and statues, including a statue of George IV on a horse as its crowning glory. However, when George IV died in 1830, Nash was sacked for spending too much money on the project. As a result, the design was scaled back and completed by another highly regarded architect, Edward Blore (1787-1879). Marble Arch was completed in 1833, with the central gates being added in 1837, just before Queen Victoria acceded to the throne. Despite its impressive nature, Marble Arch never sat completely comfortably next to Buckingham Palace, and in 1850 it was decided to move it to its current location, as an entrance to Hyde Park. This was done, stone by stone, in a mere three months.

Nearby food and drink: Ranoush Juice, at **recent.mirror.swear**, offers takeaway and limited sit-in options for Lebanese food, including shawarmas (filled pita breads).

Nearby attractions: The original statue of George IV on his horse from Marble Arch can be seen in Trafalgar Square at **onions.riches.turkey**.

Tower of London

Photo spot: Tower Wharf, River Thames.
what3words ref: united.harder.ranges

Direction: Facing north 1°N

Camera zoom: x2

Best time of day: Afternoon, with the sun to the left.

Additional shot: If you take a tour of the Tower of London (entrance fee applies) you will not be allowed to take any photos of the Crown Jewels.

Selfie spot: If you take a tour of the Tower of London, as above, you will be able to capture a selfie with the famous Beefeaters (officially known as Yeomen Warders) in their easily identifiable red uniforms.

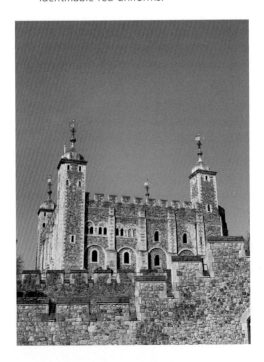

...cont'd

About this photo

Nearest Tube station: Tower Hill, exiting onto Trinity Square, at **below.laying.number**.

Getting there: Walk south down Trinity Square and turn right into Tower Hill, at **mirror.slower.gives**. After 100 metres, turn left into Tower Hill Terrace, which becomes Petty Wales. Continue south along Petty Wales for 120 metres and join Tower Wharf, at **loss.prove.anyone**. Walk east along Tower Wharf for 200 metres to get to the photo spot.

Photo fact: The Tower of London has been the location for some of the most gruesome episodes in the history of England, and it continues to exude a dominant presence to this day as it keeps a steely watch over the River Thames, guarding – among other things – the Crown Jewels. Although not originally built as a prison, this is what the Tower of London was largely used for, and it witnessed numerous executions over the centuries and was the centre of political intrigue for many of the British monarchs. One of its most famous inmates was Elizabeth I, who was imprisoned here by her sister, Mary, Queen of Scots, although it was not long before Elizabeth gained her revenge with the execution of Mary. Other notable inmates of the Tower included Sir Walter Raleigh, Thomas Cromwell (Henry VIII's chief minister), and Lady Jane Grey, whose nine-day reign as Queen was the shortest in British history. Today, the Tower of London is home to the 32 Yeoman Warders, who guard it in the name of the reigning monarch.

Nearby food and drink: The New Armouries Café within the Tower of London offers hot meals, snacks and a range of drinks.

Nearby attractions: The Tower of London also lays claim to being the first zoo in London, with a range of exotic animals in the Royal Menagerie, which now contains metal sculptures of some of these animals.

Tower Bridge

Photo spot: The Queen's Walk, River Thames.
what3words ref: beam.dine.awards

Direction: Facing northeast 60°NE

Camera zoom: x1

Best time of day: Afternoon, with the sun to the left.

Additional shot: Standing on Tower Bridge itself is a good way to capture a photo showing the impressive engineering of the bridge.

 Selfie spot: Capture a selfie so that your face appears over the Thames, with Tower Bridge looming above you.

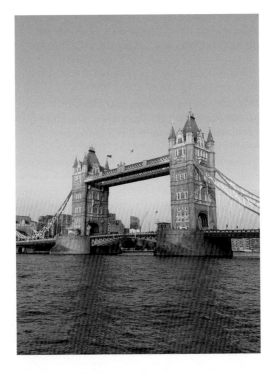

...cont'd

About this photo

Nearest Tube station: London Bridge, exiting onto Tooley Street, turning right at **liver.limp.short**.

Getting there: Walk east along Tooley Street for 150 metres and turn left down Hay's Lane, at **feels.driver.acted**, to reach The Queen's Walk, turning right. Walk 475 metres along The Queen's Walk to reach the photo spot.

Photo fact: Sometimes confused with London Bridge (of the famous song, as in "London Bridge is falling down"), Tower Bridge is a sight that is immediately connected with London. Sometimes erroneously called a drawbridge, Tower Bridge is actually a bascule bridge, which means that the sections of road that open upwards to allow shipping to pass below are controlled by a seesaw mechanism, as they are too heavy to be raised by chains or ropes that are used in a drawbridge. Tower Bridge was built between 1886 and 1894, after over 50 potential designs were submitted. The architects commissioned to design the bridge were Sir Horace Jones (1819-87) and John Wolfe Barry (1836-1918). Around 800 vessels still pass below the bridge's bascules each year, and over the years this has included the Royal Yacht Britannia. Parts of Tower Bridge can be visited by the public, for an entrance fee, including the Engine Room and the high-level glass walkways.

Nearby food and drink: The Real Greek, at **life.scans.proud**, is a great location to enjoy some meze and other Greek delights in the shadow of Tower Bridge.

Nearby attractions: Hay's Galleria to the west of Tower Bridge, on The Queen's Walk, at **cups.lifts.fans**, is the site where tea clippers used to deliver their goods in the 19th century.

Kensington Palace

Photo spot: Kensington Gardens.
what3words ref: bucked.copper.relate

Direction: Facing northwest 337°NW

Camera zoom: x1

Best time of day: Morning, with the sun behind.

Additional shot: The ornate gates at the front of Kensington Palace create an artistic photo if they fill the frame in front of the palace.

Selfie spot: Move to the right-hand side at the photo spot to capture a selfie with Kensington Palace, without the gates.

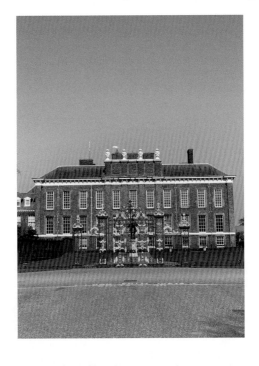

...cont'd

About this photo

Nearest Tube station: High Street Kensington. Exit the Tube station and turn right onto Kensington High Street at **lifted.mime.apple**.

Getting there: Continue along Kensington High Street for 400 metres and turn left into Palace Avenue at **facing.body.caller**. Continue for 200 metres along Palace Avenue and turn right into Studio Walk, entering Kensington Gardens at **below.hers.super**. Walk along Studio Walk to get to the photo spot.

Photo fact: Kensington Palace is one of the royal residences in London, currently the official residence of the Duke and Duchess of Cambridge. Designed largely by Christopher Wren, the architect who also designed St. Paul's Cathedral, Kensington Palace was developed from the existing Nottingham House and was first used as a royal residence by King William III and Queen Mary II, who moved in there in 1689. This set a pattern for monarchs using the palace, until 1760 with the death of George II. After this, Kensington Palace was used by minor royalty, but no monarchs lived there again. Queen Victoria was born in Kensington Palace in 1819, but moved to Buckingham Palace when she acceded to the throne in 1837. The palace was badly damaged during the Blitz in 1940, but was restored in the decades that followed. Princess Diana had apartments in Kensington Palace and lived there with her sons William and Harry after her divorce from Prince Charles. It became one of the focal points of mourning when she died in 1997.

Nearby food and drink: There is a café near to Kensington Palace, at the Diana Memorial Playground, at **stops.spent.juror**.

Nearby attractions: On the east side of Kensington Palace is the Queen Victoria Statue in front of the palace, at **melt.plus.luck**.

The Albert Memorial

Photo spot: South Carriage Drive, Hyde Park.
what3words ref: fork.offers.ridge

Direction: Facing northwest 326°NW

Camera zoom: x1.5

Best time of day: Morning, with the sun behind.

Additional shot: Move closer to the memorial and zoom in to get a photo of the gilt statue of Prince Albert in the centre of the memorial.

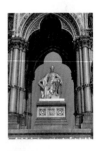

 Selfie spot: Stand on the steps below the memorial to capture a selfie with this extravagant monument.

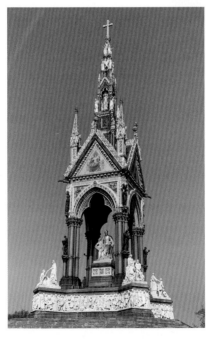

...cont'd

About this photo

Nearest Tube station: South Kensington. Exit the Tube station and turn right onto Kensington High Street at **lifted.mime.apple**.

Getting there: Follow the directions for Kensington Palace on page 85 but continue along Kensington High Street, which becomes Kensington Road. Continue along Kensington Road for 750 metres to reach the photo spot.

Photo fact: If ever there was any debate about how fond Queen Victoria was of her husband Prince Albert, the memorial in his name should dispel any doubts. It is an imposing and elaborately ornate monument that dominates the south side of Kensington Gardens, next to the Royal Albert Hall. The memorial (officially known as the Prince Consort National Memorial) was commissioned by Queen Victoria after the death of Prince Albert in 1861, and was opened over 10 years later in 1872. The cost was as extravagant as the design of the memorial, much of it met by public donations. Designed by George Gilbert Scott (1811-78) after an extensive selection process, the memorial is not only a very visible memorial to Albert but also recognises his extensive interests, with the four corner pieces depicting different areas of the world. Around the base of the memorial is the Frieze of Parnassus, which consists of 187 notable figures from the arts – one of Albert's great passions. The centrepiece of the memorial is a gilt bronze statue of Albert that was later covered in gold leaf, following restoration that was completed in 2006.

Nearby food and drink: Behind the Albert Memorial in the photo is the Albert Memorial Kiosk, for tea, coffee and snacks.

Nearby attractions: Although not nearby, there is a similar monument in memory to Prince Albert in Manchester, at **early.inform.cool**.

Royal Albert Hall

Photo spot: Prince Consort Road, Kensington.
what3words ref: snow.snow.surely

Direction: Facing north 343°N

Camera zoom: x1.5

Best time of day: Afternoon, with the sun behind.

Additional shot: Students from the Royal College of Music, opposite the photo spot, sometimes practise in front of the hall, which can make for an effective photo, but ask them for permission to take a photo first.

Selfie spot: Sitting on the steps in front of the hall is a good way to capture a selfie with the impressive dome behind you.

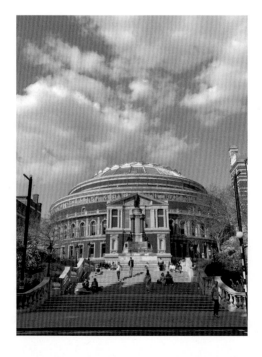

...cont'd

About this photo

 Nearest Tube station: South Kensington. Follow the signs through the underground walkway from South Kensington Tube station, exiting at the sign for the Royal Albert Hall, at the junction of Imperial College Road and Exhibition Road, at **match.retire.driver**.

 Getting there: Continue north along Exhibition Road for 200 metres, turning left into Prince Consort Road. Walk 180 metres to the photo spot.

 Photo fact: The Royal Albert Hall is famous around the world for hosting the Last Night of the Proms classical music performance. However, it is much more than just a music venue, and caters for events as diverse as circus performances to tennis competitions. The Royal Albert Hall was opened by Queen Victoria in 1871, yet another London landmark named after her husband. The dominant feature is its impressive dome, which was constructed from glazed iron and tested near Manchester before it was transported in pieces to London for its final installation. The Proms concerts, officially known as the BBC Sir Henry Wood Promenade Concerts, have been performed at the Royal Albert Hall since the end of World War II and consist of eight weeks of concerts and performances, culminating in the boisterous Last Night of the Proms. The list of famous names who have performed at the Royal Albert Hall is extensive, including Albert Einstein, Muhammad Ali, the Dalai Lama, Liza Minnelli and Adele.

 Nearby food and drink: There is a café in the foyer of the Royal Albert Hall that can be used even if you are not attending an event.

 Nearby attractions: In the walkway on the way to the Royal Albert Hall you also pass exits for the Victoria and Albert Museum and the Natural History Museum.

Covent Garden

Photo spot: Covent Garden.
what3words ref: barn.stored.slot

Direction: Facing northeast 63°NE

Camera zoom: x1

Best time of day: Any; indoors.

Additional shot: Street performers can be seen at Covent Garden at most times of the day, and they can provide good photo opportunities as they go through their acts.

 Selfie spot: If you want a selfie with any of the street performers at Covent Garden, ask permission first – any donations are gratefully received.

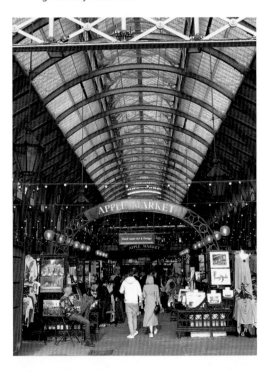

...cont'd

About this photo

Nearest Tube station: Covent Garden, exiting onto James Street, at **remedy.penny.occurs**.

Getting there: Walk 125 metres south along James Street to get to the entrance to Covent Garden. Walk through the covered area to get to the photo spot.

Photo fact: Markets have played a prominent role in London life for centuries, and dozens of them continue to this day. These range from the Smithfield Market, the largest wholesale meat market in the UK, to outdoor markets, such as the one in Petticoat Lane in Spitalfields, which specialises in clothing. However, one of the most famous London markets, Covent Garden, has evolved into a sophisticated shopping and dining experience, complete with an array of buskers and street performers in the square on its east side. Originally, Covent Garden was one of London's major fruit and vegetable markets, dating back to the early 17th century, and it soon became the most famous market in the country. In 1830 permanent structures were added to the market, and flowers became one of its central features. The main market element of Covent Garden was moved to a site in Battersea in 1974 but a semblance of its old market spirit endures with the Apple Market, selling a variety of handmade arts and crafts; the East Colonnade Market, selling items including jewellery, clothing and sweets; and the Jubilee Market, with rotating offerings depending on the day of the week.

Nearby food and drink: Covent Garden caters for most eating and drinking needs, from fine-dining restaurants to street-food takeaways.

Nearby attractions: The London Transport Museum, in the southeast corner of Covent Garden, at **cubes.large.second**, contains a fascinating collection of London transport over the centuries.

Eros (Anteros) Piccadilly Circus

Photo spot: Piccadilly Circus.
what3words ref: truth.cards.soon

Direction: Facing northeast 54°NE

Camera zoom: x5

Best time of day: Afternoon, with the sun behind.

Additional shot: One of the best times to visit Piccadilly Circus is at night when the neon advertisements around the square are lit up – this makes for good photos.

 Selfie spot: From the base of the statue capture a selfie with Eros (Anteros) at the top, but don't try to stand in the fountain!

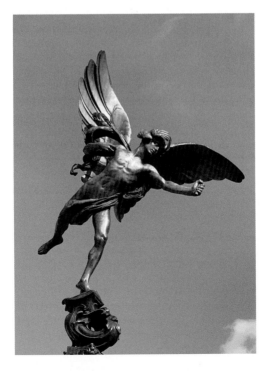

...cont'd

About this photo

Nearest Tube station: Piccadilly Circus. Exit the Tube station at **margin.bike.jumps**.

Getting there: Walk around the south side of Piccadilly Circus to get to the photo spot.

Photo fact: Although Piccadilly Circus is one of the iconic names associated with London, it has little to offer those on a city break, other than to tick it off the list of places visited. It is a rather gaudy square, surrounded by tourist shops of debatable quality. The main attraction in Piccadilly Circus is the aluminium statue in the fountain on the south side of the square. Generally known as Eros, the figure on top of the statue is actually his brother, Anteros, the Greek god of requited love. The statue itself is officially the Shaftesbury Memorial Fountain, in memory of Anthony Ashley Cooper, the 7th Earl of Shaftesbury. Designed by the sculptor Alfred Gilbert (1854-1934), the statue was unveiled in 1893 and Londoners were generally unimpressed, with complaints ranging from the state of undress of Anteros to the splashing from the fountain below. Over the years the statue has been a magnet for vandalism and boisterous behaviour, suffering numerous traffic cones being placed around it and several pieces being broken off. In 2013 the statue suffered a further indignity when it was encased in a snowdome to promote Piccadilly Circus. Despite its checkered history, the erroneously named Eros endures as a popular symbol of tourist London.

Nearby food and drink: Piccadilly Circus is not the most relaxing dining location, and better options can be found in nearby Leicester Square.

Nearby attractions: To the west of Piccadilly Circus is Regent Street, one of London's most exclusive shopping and dining locations.

St. Paul's Cathedral

Photo spot: Cannon Street.
what3words ref: deeper.dent.foam

Direction: Facing northwest 320°NW

Camera zoom: x1.2

Best time of day: Morning, with the sun behind.

Additional shot: Walk behind St. Paul's Cathedral to see the golden statue of Saint Paul, at **store.leaned.eagle**.

 Selfie spot: Walk as close as possible to the cathedral and use a selfie stick to capture a selfie, with your smartphone as low as possible to the ground, for a sense of the size of the cathedral and the dome.

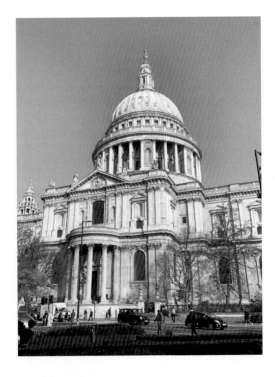

...cont'd

About this photo

Nearest Tube station: St. Paul's. Exit the Tube station and turn right onto Cheapside at **grants.renew.exist**.

Getting there: Continue south along Cheapside, becoming New Change, for 240 metres, turning right up Cannon Street at **encounter.match.fats**. Walk 100 metres along Cannon Street/St. Paul's Churchyard to get to the photo spot, crossing the road at **nods.pits.reply**.

Photo fact: The current St. Paul's Cathedral was one of the major projects constructed during the extensive building works undertaken following the Great Fire of London in 1666. Famously designed by Sir Christopher Wren (1632-1723), St. Paul's Cathedral is one of over 50 churches he designed, as London began to rebuild after the Great Fire. The design and construction took several decades, being consecrated in 1697, with the iconic dome becoming the centrepiece of what is still the second largest church in the UK, after Liverpool Cathedral, and it remained the tallest building in the UK until 1963. St. Paul's has held the funerals of many famous people, including the Duke of Wellington and Sir Winston Churchill, and has been visited by luminaries including Martin Luther King. It has also had to shoulder its share of misfortune, from a failed bomb plot by the Suffragettes to the very real bombing during the Blitz in 1940 and 1941, St. Paul's has endured as a symbol of London's resilience, regardless of what is thrown at it.

Nearby food and drink: Mangio Pasta and Bottega, at **maker.beam.cats**, offers fresh pasta, salads, and more for a light lunch.

Nearby attractions: Across the road from St. Paul's Cathedral is The National Firefighters Memorial, at **union.piles.newest**. This is a memorial to firefighters who lost their lives in the line of duty, and depicts three figures in action during the Blitz in 1940 and 1941.

Millennium Bridge St. Paul's

Photo spot: Bankside, River Thames.
what3words ref: state.keys.parts

Direction: Facing northeast 25°NE

Camera zoom: x2.7

Best time of day: Morning, with the sun behind.

Additional shot: Standing on the bridge, an effective shot includes St. Paul's in the middle of the bridge.

 Selfie spot: The centre of the bridge itself is also a great place to take a selfie that includes the full structure of the bridge.

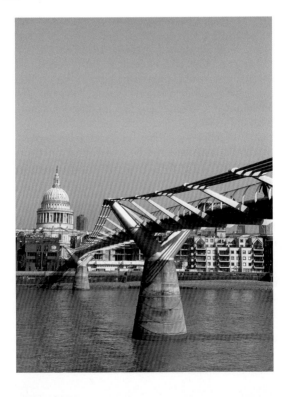

...cont'd

About this photo

Nearest Tube station: Mansion House. Exit the Tube station onto Queen Victoria Street, turning left at **goats.fuel.brave**.

Getting there: Walk 300 metres west along Queen Victoria Street and turn left into Peter's Hill, at **looked.hung.shells**. Walk to the end of Peter's Hill, joining the Millennium Bridge, and walk to the end to reach the photo spot.

Photo fact: Originally opened in June 2000 to celebrate the new millennium, the pedestrian-only Millennium Bridge quickly became famous – or notorious – for its instability as much as anything else. Officially named the London Millennium Footbridge, it was designed by the acclaimed architect Norman Foster and was the first bridge to be built over the Thames for over 100 years. The bridge was opened, with considerable fanfare, by Queen Elizabeth II on 10 June 2000. However, there was a major problem, as the bridge twisted and swayed when the first pedestrians walked across it. As a result, the bridge was closed only two days after its official opening. It took two years for the structural issues with the bridge to be resolved, and it opened for the second time on 27 February 2002. Despite the fact that the stability issues had been resolved, the bridge continues to be widely known by its nickname, "the Wobbly Bridge". The bridge has also been quick to become a firm favourite with TV and movie makers, including an appearance in *Harry Potter and The Half Blood Prince*, when it was dramatically destroyed, but thankfully only by CGI.

Nearby food and drink: Behind the Tate Modern art gallery is the Table Café, at **regard.flag.string**, which specialises in brunch.

Nearby attractions: The Tate Modern art gallery and Shakespeare's Globe theatre (see pages 98-99 for details) are both located near to the photo spot.

Shakespeare's Globe

Photo spot: Bankside, Thames.
what3words ref: dress.today.pasta

Direction: Facing south 1°S

Camera zoom: x1

Best time of day: Morning, with the sun to the left.

Additional shot: Photos of the posters advertising plays at the Globe is a good way to capture the context of the location and the theatre.

 Selfie spot: Try capturing a selfie in front of the Globe with one of your best poses from a Shakespeare play.

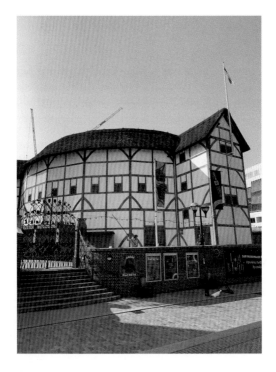

...cont'd

About this photo

Nearest Tube station: Mansion House. Exit the Tube station onto Queen Victoria Street, turning left at **goats.fuel.brave**.

Getting there: Follow the directions for the Millennium Bridge and St. Paul's on page 97. Cross the Millennium Bridge, turning left at the end at **cloud.rams.unless**. Walk 150 metres east along Bankside by the river to reach the photo spot.

Photo fact: Although Shakespeare's Globe theatre is a significant London sight, it can easily be missed when taking in some of the more familiar sights. Opened in 1997, Shakespeare's Globe is an accurate reconstruction of the famous Globe Theatre used by Shakespeare in London, from 1599 to 1613 when it was destroyed by fire. It was rebuilt in 1614, but the current Shakespeare's Globe is based on the original version. Shakespeare's Globe is the brainchild of American actor and director Sam Wanamaker (1919-93), who founded the Shakespeare Globe Trust in 1970. Dismayed that there was nothing more than a plaque to commemorate the original Globe Theatre, it became Wanamaker's life mission to recreate the Globe, as close to the original location as possible. This was achieved in 1997, but sadly Wanamaker did not live to see it opened. Today, Shakespeare's Globe produces plays by Shakespeare, and it also has an extensive educational program.

Nearby food and drink: There is a restaurant within the Globe itself, called the Swan, and the Real Greek Bankside at **stocks.kite.then** offers Greek meze for a quick lunch.

Nearby attractions: The Tate Modern art gallery is next to the Globe (entrance at **always.skin.evenly**), housed in the old Bankside Power Station. This contains one of the world's largest collections of modern art.

London Eye

Photo spot: Westminster Bridge.
what3words ref: else.slips.acid

Direction: Facing northeast 64°NE

Camera zoom: x1

Best time of day: Afternoon/early evening, with the sun to the right-hand side.

Additional shot: The view from the London Eye is an excellent option for capturing panoramic shots of London.

 Selfie spot: If you take a ride on the London Eye, make sure you get a selfie with the London cityscape behind you.

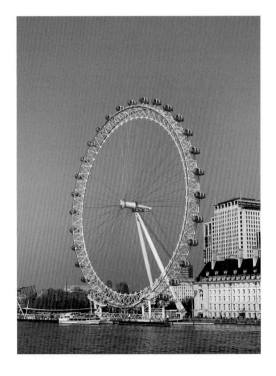

...cont'd

About this photo

Nearest Tube station: Westminster. Exit the Tube station, turning left onto Great George Street at **market.poem.about**.

Getting there: Stay on the north side of Great George Street and, heading east, cross Victoria Embankment to get to the photo spot.

Photo fact: For those with a head for heights, the London Eye is the ideal way of getting a bird's-eye view of the city. Formerly known as the Millennium Wheel, the London Eye is a cantilevered observation wheel, meaning that it is firmly supported on one side. Reaching a height of 135 metres, the London Eye has 32 passenger capsules, containing up to 25 people, that move slowly with the rotation of the wheel so that the view can be enjoyed for the whole journey of the capsule. Each rotation takes approximately 30 minutes, with the wheel moving at 26 cm per second, which is slow enough for passengers to enter and leave the capsules without the wheel stopping. At night the wheel can be lit up with different colour patterns, using the digital lighting system that was installed in 2006. Although it is not cheap to go on the London Eye (£40 at the time of printing), it has not stopped it becoming the number-one paid tourist attraction in the UK.

Nearby food and drink: Near to the entrance for the London Eye is the Great British Fish and Chips takeaway, at **cattle.woke.calls**.

Nearby attractions: Along Victoria Embankment, at **expand.skills.gallons**, is the Battle of Britain Monument to the Royal Air Force, for their services during World War II and the Battle of Britain (1940). It is also a good spot to capture a straight-on photo of the London Eye. Just before this is New Scotland Yard, the headquarters of the Metropolitan Police, with its famous rotating sign outside.

St. Pancras International

Photo spot: St. Pancras International station.
what3words ref: looked.swing.coach

Direction: Facing southeast 135°SE

Camera zoom: x1

Best time of day: Any; indoors.

Additional shot: The statue of John
Betjeman, at **faded.fork.shock**,
shows the man who campaigned to
save St. Pancras station in the 1960s.

Selfie spot: Capture a
selfie with the statue of
John Betjeman, as he stares
up at the roof he helped
to save.

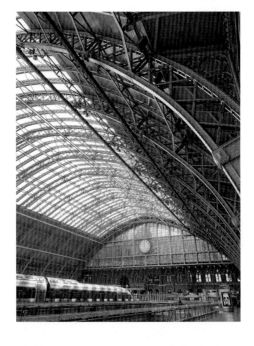

...cont'd

About this photo

 Nearest Tube station: King's Cross St. Pancras. From King's Cross station, exit at **zest.back.monday** and cross Pancras Road to St. Pancras International.

 Getting there: In St. Pancras International, follow the signs for the Eurostar train service and take the escalator, or lift, up to Level 1 to get to the photo spot.

 Photo fact: St. Pancras International station is more than just a railway station; it is a testimony to the great days of rail travel and also to people who believed in preserving this iconic construction. St. Pancras railway station opened in 1868 and was at the heart of the development of rail travel during the Victorian age. Due to its location, the construction of the station presented a number of challenges, some of which were solved by the construction of the arched roof covering most of the station below, without the need for numerous columns in the station. The roof's design was ground-breaking, and when it was completed it was the largest single-span roof in the world. The red brickwork in St. Pancras is also impressive and elegant, consisting of over 60 million bricks. In 1966, British Railways announced their intention to merge St. Pancras with nearby King's Cross, thereby dismantling much of the original St. Pancras station. The poet John Betjeman led a successful campaign to save the station, including extensive renovations, and since then it has gone from strength to strength, becoming the terminus for the Eurostar train service to Europe after the opening of the Channel Tunnel in 1994.

 Nearby food and drink: St. Pancras International contains numerous food and drink outlets, including the popular London takeaway Joe & The Juice, at **frames.shorts.sound**.

 Nearby attractions: The famous toy store, Hamleys, has an outlet in St. Pancras International, at **souk.post.places**.

The Gherkin

Photo spot: Leadenhall Street.
what3words ref: motel.demand.transfers

Direction: Facing northeast 38°NE

Camera zoom: x1

Best time of day: Afternoon, with the sun behind.

Additional shot: The Gherkin is surrounded by tall glass buildings that are excellent for trying to capture its reflection, depending on the weather and time of day. The Gherkin is also very impressive when lit up at night.

Selfie spot: Try to capture a selfie where you look as tall as the Gherkin.

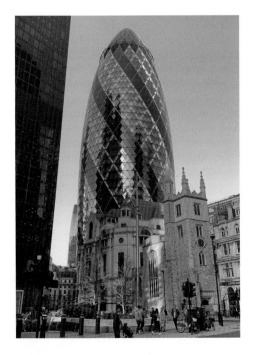

...cont'd

About this photo

Nearest Tube station: Aldgate. Exit onto Aldgate High Street, turning right at **flute.number.path**.

Getting there: Walk west along Aldgate High Street for 170 metres, crossing Mitre Street and turning right into Leadenhall Street, at **invent.hunt.parts**. Continue along Leadenhall Street for 275 metres to get to the photo spot.

Photo fact: Londoners love giving nicknames to new buildings around their city, particularly skyscrapers as they emerge over the city's horizon, and the Gherkin was one of the first to be named in this way. Opened in 2004, and known more prosaically as 30 St. Mary Axe, the Gherkin is largely an office block in the heart of the city, housing a number of major global companies. The Gherkin was designed by the renowned architects Norman Foster and Ken Shuttleworth, and the patterned glass exterior is not only a visual feature but also serves a practical purpose as it helps with the air flow for the building's energy-saving design. Standing at 180 metres tall, the Gherkin is covered by 24,000 square metres of glass, although this caused a major scare in 2005 when one of the glass panels came loose and fell to the ground. There are 18 passenger lifts in the building that can accommodate up to 378 people at a time and travel at a speed of up to six metres per second. The church in front of the Gherkin in the photo is the 15th-century St. Andrews Undershaft Church, giving a pleasing historical contrast to the ultra-modern design of the Gherkin.

Nearby food and drink: At the top of the Gherkin are the Helix restaurant and the Iris bar, both open to the public and affording stunning views across the skyline of London.

Nearby attractions: It is worth paying St. Andrews Undershaft Church a visit while you are viewing the Gherkin. The church survived the Great Plague, the Great Fire of London, and the Blitz.

Bank of England

Photo spot: Threadneedle Street.
what3words ref: cakes.caked.script

Direction: Facing north 20°N

Camera zoom: x1

Best time of day: Late morning/
early afternoon, with the sun
behind.

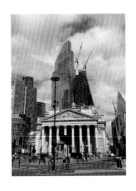

Additional shot: The Royal
Exchange, next to the Bank of
England, is a centre of commerce
in London, with modern buildings
in the background.

Selfie spot: Take a selfie holding a Bank of
England banknote, with the bank itself in the
background of the shot.

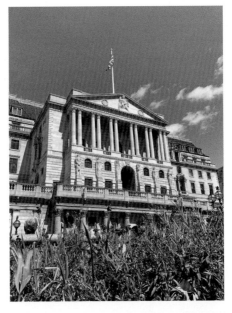

...cont'd

About this photo

Nearest Tube station: Bank. Exit the Tube station using Exit 2, onto Threadneedle Street.

Getting there: Cross to the south side to get to the photo spot, in the small square in front of the Bank of England.

Photo fact: If you want to know where the true financial power lies in London, then a visit to the Bank of England is a must. Nicknamed, "The Old Lady of Threadneedle Street", from a cartoon in 1797, the Bank of England is the central bank in the UK, and its role is to deliver financial and monetary stability for the country, through actions including setting interest rates. The Bank of England was founded in 1694, and its role was to act as the banker for the government, initially to provide funds for the war against France. In 1725 the first banknotes were issued, and nine years later the bank moved to its current location in Threadneedle Street. Between 1925 and 1939 the building was rebuilt to increase its size and prominence. In 1970 the Bank of England issued its first pictorial banknote, a £20 note featuring William Shakespeare, and in 2016 it issued its first polymer banknote, a £5 note featuring Sir Winston Churchill. The Bank of England also has its own museum detailing its history through the centuries, as it continues to be at the heart of the British financial establishment.

Nearby food and drink: The nearby St. Mary Woolnoth church, on King William Street, at **cages.chew.short**, contains The Cosy Coffee Corner café, with some seating outside at its entrance. The church itself also makes for a good photo.

Nearby attractions: There are two statues in the square in front of the Bank of England – one of the Duke of Wellington, with the other being the London Troops War Memorial.

Top Sights Details

After taking photos of any top city sights, it is worth taking a few extra minutes to see if there are any more photographic opportunities to be had. This is particularly effective if you concentrate on the details of buildings, and some options around the city include:

The gold decorations on the gates at Kensington Palace.

Some of the statues on the front of Westminster Abbey.

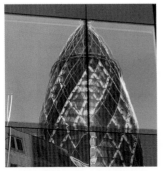

Reflections, such as the Gherkin building reflected in nearby glass structures.

5 Hidden London Photos

While many of the main sights of London are iconic and well recognised, there are also numerous locations that offer excellent photographic opportunities, but they are not as well known as sights such as Buckingham Palace or Big Ben. In addition, these sights illustrate a different side to London and provide an opportunity to delve a bit deeper into the character and history of the city.

Some of the less well-known sights include: the eccentric Hardy Tree, piled up with tombstones at its base; the peaceful and thought-provoking Postman's Park, dedicated to ordinary people who gave their lives saving others; St. Stephen Walbrook church, one of Sir Christopher Wren's masterpieces; and the statue of Paddington Bear, in the station that gave him his name.

This chapter delves into some fascinating sights in London that could easily be missed when trying to fit in all of the top sights. However, if you seek them out, then you will be rewarded with some memorable locations and stories.

The Hardy Tree

Photo spot: St. Pancras Old Church.
what3words ref: blues.orders.forced

Direction: Facing southeast 129°SE

Camera zoom: x1.2

Best time of day: Afternoon, with the sun behind.

Additional shot: St. Pancras Old Church is a charming photo opportunity in its own right.

Selfie spot: There is a wire fence around the Hardy Tree, but if you walk around it there is an opening where you can get closer to the tree and take a selfie here.

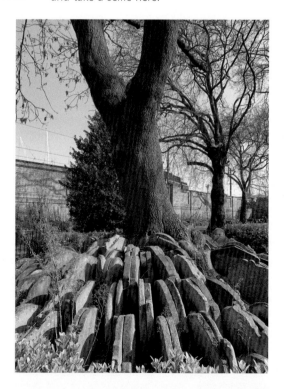

...cont'd

About this photo

Nearest Tube station: King's Cross St. Pancras. Exit the Tube station from King's Cross station, turning right into Pancras Road at **fresh.toxic.keeps**.

Getting there: Walk along Pancras Road for 250 metres and turn left under the walkway at **papers.audit.proof**. Turn right at the end of the walkway, still on Pancras Road, at **arrive.truly.serve**, and continue until you reach St. Pancras Old Church on the right-hand side at **shops.status.stacks**. Walk around the church to reach the photo spot.

Photo fact: Every city has its share of quirky and eccentric sights, and the Hardy Tree is certainly one of London's. Its existence owes much to the expansion of the railways in London during the 19th century, and in 1860 part of this expansion included new lines from St. Pancras station that would run directly through a nearby graveyard. To accommodate the railway, an architects' firm was commissioned to exhume the graves and move them to another location. It was a job that no-one in the firm really wanted to do, so it was delegated to one of the office's most junior members – a certain Thomas Hardy. Once the bodies had been moved, there was a considerable number of tombstones left, and Hardy decided to stack them up around the base of an ash tree in the nearby St. Pancras Old Church. As well as this contribution to London life, Thomas Hardy is better known as the classical novelist who wrote titles including *Tess of the D'Urbervilles* and *Far From the Madding Crowd*.

Nearby food and drink: There are benches at the front of the church and around the graveyard that are ideal for a quiet picnic.

Nearby attractions: Situated in the St. Pancras Old Church graveyard, the Sir John Soane monument is a Grade 1-listed monument that records the death of the man who was the architect for the design of the Bank of England.

St. Dunstan in the East

Photo spot: St. Dunstan's Hill.
what3words ref: agree.garden.burn

Direction: Facing north 2°N

Camera zoom: x1.2

Best time of day: Mid-morning, with the sun behind.

Additional shot: Almost any area of the church is worthy of more photos, particularly the corner with a palm tree near the entrance.

Selfie spot: As with taking additional photos, the whole church has potential for selfies, although make sure that there are no other people in the way of your shot.

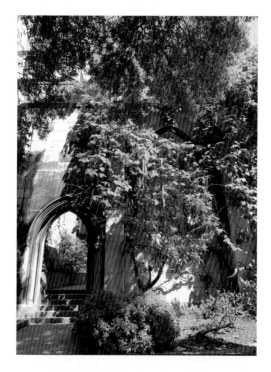

...cont'd

About this photo

Nearest Tube station: Monument. Exit the Tube station onto Eastcheap at **liver.priced.tones**.

Getting there: Walk east along Eastcheap for 200 metres, when it becomes Great Tower Street. Continue for another 100 metres and turn right along St. Dunstan's Hill at **first.pound.lakes**. Walk 50 metres along St. Dunstan's Hill to enter the church at **cheeks.nation.shared** and reach the photo spot.

Photo fact: Considering that it is in the very heart of the City of London, St. Dunstan in the East is something of a miracle of peace and contemplation. Named after a 10th-century monk, St. Dunstan in the East has had a colourful and eventful history. As with much of the city it suffered extensive damage during the Great Fire of London in 1666, and much of the existing church was destroyed by German bombs during the Blitz in 1941. However, this has contributed greatly to its current charm, with a variety of trees, vines and even palms growing around the ruined church, after it was turned into a public park that opened in 1970. With plenty of benches and seating areas, St. Dunstan in the East is the perfect place to take a break and recharge the batteries on a busy day sightseeing. However, it can get busy with tourists and Instagrammers, so the best time to visit is usually early in the morning.

Nearby food and drink: Continue along Great Tower Street to get to the Hung, Drawn and Quartered pub, which serves excellent traditional homemade pies, at **soak.chip.wrong**.

Nearby attractions: On the way to St. Dunstan in the East you pass the massive Fenchurch Building, known affectionately as "The Walkie Talkie". This also houses the Sky Garden (see pages 122-123 for details).

Leadenhall Market

Photo spot: Gracechurch Street.
what3words ref: Market entrance **event.thick.prices**;
photo spot **lion.both.museum**

Direction: Facing west 240°W

Camera zoom: x1

Best time of day: Anytime; indoors.

Additional shot: Capture some close-ups of the produce on display and the fashionable items in some of the boutiques.

 Selfie spot: A selfie with the arched roof of Leadenhall Market makes for an effective shot.

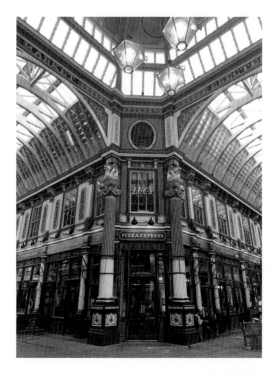

...cont'd

About this photo

Nearest Tube station: Monument. Exit the Tube station onto King William Street at **faded.rating.stump**, turning left into Gracechurch Street.

Getting there: Cross to the east side of Gracechurch Street and continue north for 200 metres to get to the photo spot.

Photo fact: London has a great history of markets, and through the centuries they have not only contributed to the commercial development of the city but also its very character. Leadenhall Market is one of the oldest markets in the city, with evidence that there was a market on the site dating back to Roman times, when the city was known as Londinium. Since then, Leadenhall Market was gifted to the city by Lord Mayor Richard Whittington (made famous as Dick Whittington) at the beginning of the 15th century, and survived plague and fire during the 17th century to become a thriving market selling meat, fish, and a variety of other goods. The market was redesigned in the 19th century, with its impressive Victorian arcade structure and intricate glass roof, and many of its features have been retained to this day. In 2021 Leadenhall Market celebrated its 700th anniversary and it goes from strength to strength with its mouth-watering range of food stalls, cafés and dining options, and modern boutique shopping opportunities.

Nearby food and drink: Leadenhall Market has a plethora of eating and drinking experiences, all under its own roof.

Nearby attractions: The Gherkin building, officially and more prosaically known as 30 St. Mary Axe, at **dose.gates.junior**, is a five minute walk from Leadenhall Market (see pages 104-105 for details).

Great Fire Monument

Photo spot: Monument Square.
what3words ref: **spin.hardly.editor**

Direction: Facing east 86°E

Camera zoom: x1.5

Best time of day: Late afternoon, with the sun behind.

Additional shot: There is a Latin inscription at the foot of the monument, and also an English translation.

 Selfie spot: Use a selfie stick to get as much of the monument in a selfie as possible.

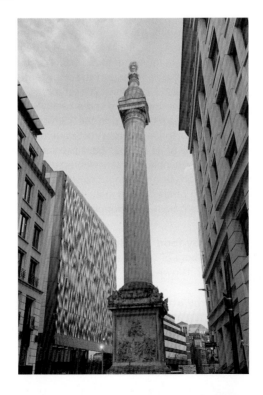

...cont'd

About this photo

Nearest Tube station: Monument. Exit the Tube station onto King William Street at **diner.judges.format**.

Getting there: Walk south along King William Street for 50 metres and turn left into Monument Street at **vital.mining.battle**. Walk east along Monument Street for 50 metres to get to the photo spot.

Photo fact: London has been prone to damaging fires through the centuries, partly due to the tightly packed houses, generally constructed from wood and thatch. However, what was to become known as the Great Fire of London in 1666 was the most devastating of them all. The Great Fire started in September in the house of the King's baker, Thomas Farriner, in Pudding Lane, although the exact cause of the fire was never established. Since it had been a particularly hot summer in London, the timber and thatch houses were ready fuel for the fire and it raged through the city for nearly five days. Once it was finally under control, 80% of the city had been destroyed, although there were only six deaths reported as a result of the fire. The Great Fire of London was a traumatic event for its citizens, and many thought it was an act of God due to the city's – at times – decadent nature. Others were more pragmatic and saw it as an opportunity to rebuild a city that was more fit for purpose. This was started with the Rebuilding of London Act 1666 that stipulated, among other things, that brick and stone should be used for the construction of houses.

Nearby food and drink: Scarpetta on Cannon Street, to the west of Monument Tube station, at **tips.suffice.known**, is a good option for an Italian lunch or dinner.

Nearby attractions: To the west of Monument Tube station, on Cannon Street, is London Stone, at **spine.fumes.knee**, a once-iconic part of London life (see pages 118-119 for details).

London Stone

Photo spot: Cannon Street.
what3words ref: spine.fumes.knee

Direction: Facing north 7°NW

Camera zoom: x1

Best time of day: Any.

Additional shot: At night,
London Stone itself is illuminated,
creating a bright centre for a
photo.

 Selfie spot: You will
have to crouch down
to get the best selfie
with London Stone.

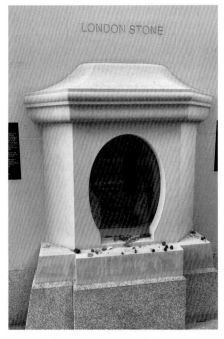

...cont'd

About this photo

Nearest Tube station: Cannon Street, turning right onto Cannon Street, at **barks.love.closes**.

Getting there: Cross to the north side of Cannon Street and walk east for 50 metres to reach the photo spot.

Photo fact: Thousands of people walk past London Stone every day, unaware of the central role that it once played in the history of the city. Now rather neglected and unloved on a busy city street, London Stone was once considered to have almost mythical properties. For centuries it was thought in some quarters to have been the stone of Brutus, when the Romans occupied the land around what was to become London. Its first historical reference is by the great English historian John Stow (c.1525-1605). The reputation of London Stone developed during the 16th and 17th centuries, and it was frequently used as a reference point on maps, as well as being a landmark in its own right. Stories about it abounded, including one that claimed that it represented the very centre of the city. The popularity of London Stone endured up until the 20th century, but the Blitz during World War II signalled a decline in its popularity, and it was moved to its current unassuming location in 2018. Although few of the stories and legends surrounding London Stone are verifiable, it remains an important reminder of the city's history.

Nearby food and drink: The Caravan City, located in the Bloomberg Arcade on Cannon Street, at **pile.modest.vital**, is a fashionable restaurant/bar with a strong coffee culture.

Nearby attractions: Within a 10-minute walk are four more hidden photo sights: the Great Fire Monument (see pages 116-117); St. Dunstan in the East (see pages 112-113); the Sky Garden (see pages 122-123); and Leadenhall Market (see pages 114-115).

St. Stephen Walbrook

Photo spot: Walbrook, off Cannon Street.
what3words ref: **reward.begins.will**

Direction: Facing southeast 140°SE

Camera zoom: x1

Best time of day: Any; indoors.

Additional shot: Directly behind
the photo spot is the church's organ,
with its impressive black facing.

 Selfie spot: Be respectful
when taking selfies as St.
Stephen Walbrook is still
an active church.

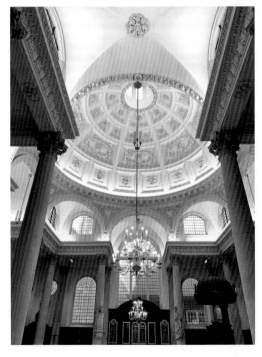

...cont'd

About this photo

Nearest Tube station: Cannon Street, turning right onto Cannon Street, at **barks.love.closes**.

Getting there: Cross to the north side of Cannon Street and turn right into Walbrook, at **wires.sushi.churn**. Continue 120 metres to reach the photo spot.

Photo fact: Although Sir Christopher Wren is rightly famous around the world for his design of St. Paul's Cathedral, he also designed over 50 other churches and buildings around London, mainly as a result of the Great Fire of London in 1666. One of those churches is St. Stephen Walbrook, and it is considered to be one of Wren's masterpieces. A church near to this site has existed for over 1,000 years and there has been a church on the current site since 1428. After Wren rebuilt St. Stephen Walbrook, the dome was acclaimed as some of his finest work and a prototype for St. Paul's, although much of it was destroyed during World War II and had to be restored. The church has other claims to fame too, as it was where the Samaritans was founded in 1953 by the Reverend Chad Varah. One of the ironies about this historic church is that the ubiquitous Starbucks now nestles around its exterior, as a reminder that modern life is all around in London.

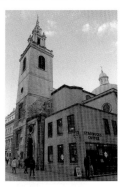

Nearby food and drink: If you are a lover of Starbucks, you can try the one around the side of the church.

Nearby attractions: London Mithraeum. On the way to the church, along Walbrook at **them.acute.orbit**, is this free museum exhibiting the remains of an old Roman temple.

Sky Garden

Photo spot: 20 Fenchurch Street.
what3words ref: **upgrading.entry.scars**, albeit 35 floors above ground level.

Direction: Facing south 190°S

Camera zoom: x1

Best time of day: Any.

Additional shot: The Sky Garden is an actual garden, and its plants can make for some good high-altitude shots.

Selfie spot: If you have a head for heights, excellent selfies can be taken from the Sky Garden's outdoor terrace (weather permitting).

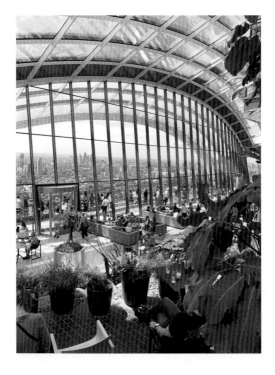

...cont'd

About this photo

Nearest Tube station: Monument, exiting onto Eastcheap, at **crown.shops.ample**.

Getting there: Walk 100 metres east along Eastcheap and turn left along Philpot Lane, at **dawn.eating.cones**. Continue 60 metres along Philpot Lane to reach the entrance to the Fenchurch Building, at **young.pose.jobs**, where an elevator will take you to the Sky Garden.

Photo fact: While excellent views of London can be seen from the London Eye, equally spectacular views can be seen from another landmark, and it's free! Located in the building known as "The Walkie-Talkie" (officially named 20 Fenchurch Street and also known as the Fenchurch Building), the Sky Garden at the top provides panoramic views of the London skyline. Although it is free to go up to the Sky Garden, it is best to book (which can be done online) up to three weeks in advance. The Sky Garden is the highest public garden in London and it is also used for activities, including yoga and live music. The building itself,

which opened in 2015, has not been without controversy, including winning the Carbuncle Cup in 2015 for the country's worst new building of the year, and there were also problems with solar-glare and wind-tunnel effects in the streets around the base of the building.

Nearby food and drink: The Sky Garden has two restaurants – the Darwin Brasserie and the Fenchurch Restaurant, and three bars – the Sky Pod, City Garden, and Fenchurch Terrace.

Nearby attractions: Being so high above the ground there are few nearby sights, but you can see landmarks including Tower Bridge and the Gherkin building from the Sky Garden.

Kyoto Garden

Photo spot: Holland Park.
what3words ref: slam.gasp.period

Direction: Facing east 109°E

Camera zoom: x1

Best time of day: Afternoon, with the sun to the right.

Additional shot: Take some time to wander around the Kyoto Garden and make the most of the photographic opportunities that occur at almost every turn.

 Selfie spot: There is a small concrete bridge in front of the photo spot, and if you stand on this you should be able to capture a selfie with the waterfall behind you.

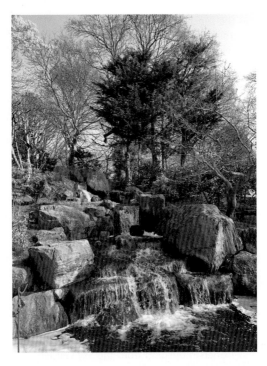

...cont'd

About this photo

Nearest Tube station: Holland Park. Exit the Tube station to the left, onto Holland Park Avenue, at **saving.broken.glove**.

Getting there: Heading east, cross Lansdowne Road and walk 70 metres along Holland Park Avenue. Cross the road and turn right along Holland Park (road) at **arrow.bring.gossip**. Continue along the east side of Holland Park for 200 metres, turning left into Holland Park (the park) at **flown.bravo. supper**. Walk 220 metres along the path and turn right at **rugs.future.pinks**. Continue on the path for 175 metres, turning left at **crush.calm.wing**, and walk for 50 metres. Turn left at **extend.normal.games** to reach the photo spot.

Photo fact: London is very well served by gardens, both big and small. The Kyoto Garden falls into the latter category. Part of the larger Holland Park, the Kyoto Garden was opened in 1991 as a gift from the city of Kyoto in Japan, to mark an enduring friendship between Japan and the UK. The Kyoto Garden is an artistic and delicate Japanese garden with a waterfall and a pond, and it is surrounded by delicate Japanese maple trees.

Nearby food and drink: There is a café in Holland Park, at **action.famed.wooden**.

Nearby attractions: Fukushima Memorial Garden. Located nearby, also in Holland Park, the Fukushima Memorial Garden was opened in 2012 as a sign of gratitude from Japan to the British people for their support following the devastating earthquake and tsunami that hit northern Japan in 2011.

Postman's Park

Photo spot: King Edward Street.
what3words ref: pizza.these.wicked

Direction: Facing west 261°W

Camera zoom: x1.5

Best time of day: Any, as the park is largely sheltered by surrounding buildings.

Additional shot: The individual tiled plaques make for sobering photos of the bravery of the people involved.

 Selfie spot: Postman's Park is a place for some quiet reflection rather than for taking selfies, although some can be taken with the flower beds in the park.

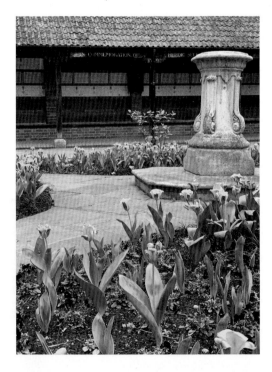

...cont'd

About this photo

Nearest Tube station: St. Paul's. Exit the Tube station onto Cheapside, turning left at **reap.frost.weeks**.

Getting there: Cross to the north side of Cheapside, as it becomes King Edward Street. Turn right up King Edward Street at **bids.listed.mutual** and continue along the east side for 150 metres. Turn right into Postman's Park at **priced.down.dine** to reach the photo spot.

Photo fact: One of the delights about

London is that there are numerous hidden quiet treasures that are merely a few metres from the busy city streets. One of these is Postman's Park, a small garden area that seems far removed from the bustling city life around it. However, Postman's Park is not only a peaceful and well-designed garden area but is also a memorial to ordinary London residents who gave their lives performing selfless acts to save other people. The memorial contains 54 tiled plaques, each detailing the heroic acts of those who died in acts of great bravery for others, and who otherwise may have been forgotten with the passing of time. The name of the park comes from the headquarters of the General Post Office, which was formerly on the site.

Nearby food and drink: Postal workers used the park to eat their lunch in, and this is still a good option today.

Nearby attractions: The Museum of London is a five-minute walk north of Postman's Park, on Algersgate Street, at **life.marble.unit**, and offers a fascinating insight into the city, from prehistoric times to the present day. It is free but needs to be booked.

Dickens Inn

Photo spot: St. Katharine Docks Marina.
what3words ref: rotate.many.spring

Direction: Facing northeast 35°NE

Camera zoom: x2

Best time of day: Late afternoon, with the sun behind.

Additional shot: The Dickens Inn is located on the St. Katharine Docks Marina and this makes for a good photo opportunity, capturing the boats that are moored there.

Selfie spot: It may not be Dickensian, but a selfie with the colourful background of the Dickens Inn is one to brighten up any collection.

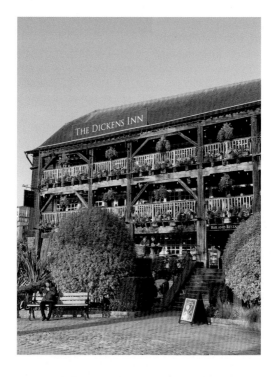

...cont'd

About this photo

Nearest Tube station: Tower Hill. Exit the Tube station into Trinity Square, turning left at **drama.serves.stable**.

Getting there: Walk 90 metres and turn left into Tower Hill at **shapes.achieving.launch**. Follow Tower Hill, heading east, crossing over to St. Katharine's Way at **puzzle.return.wires**. Continue down St. Katharine's Way, heading south for 200 metres, turning left at **danger.origin.foster**. Follow St. Katharine's Way for a further 170 metres and turn left along the path at **noted.pouch.crowd**. Walk along the path for 100 metres to reach the photo spot.

Photo fact: Despite its name, the Dickens Inn has little concrete connection with one of the world's most famous writers, Charles Dickens (1812-70), other than it was formally opened by his grandson, Cedric Charles Dickens, in 1976. However, it is located in an area of London that Dickens knew well, and where he spent many hours walking and observing people and locations for his novels. One of the main attractions of the Dickens Inn is its extensive floral displays that cover much of the outside of the building.

Nearby food and drink: Once you get to the Dickens Inn there is no need to look any further for food or drink, as both are extensively catered for here.

Nearby attractions: The Girl With a Dolphin statue, near to the beginning of St. Katharine's Way, next to Tower Bridge, at **armed.oath.joins**, is an eye-catching design, with very little seemingly holding up this evocative statue.

Leake Street Arches

Photo spot: Leake Street.
what3words ref: mining.layers.saves

Direction: Facing southeast 120°SE

Camera zoom: x1

Best time of day: Any.

Additional shot: Close-up shots of the artwork in the Leake Street Arches is a must, but if you are going to be displaying this on social media, make sure that there are no potentially offensive words or phrases in the photos.

 Selfie spot: If artists are working in the tunnel you could capture a selfie with them at work, but always ask for permission first.

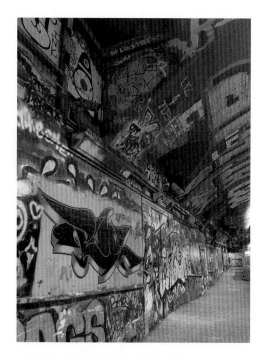

...cont'd

About this photo

Nearest Tube station: Waterloo, exiting via Exit 5, at **costs.trace.until**, and turn left into Cab Road.

Getting there: Walk 50 metres to the end of Cab Road and turn left into York Road, at **strike.shrimp.useful**. Continue 225 metres along York Road and turn left into Leake Street, at **unfair.freed.duck**. Walk along Leake Street for 75 metres to get to the tunnel entrance.

Photo fact: The expressive arts are well represented throughout London, and graffiti and urban art is a significant component of this. Nowhere has this been more comprehensively embraced than the Leake Street Arches, also known as the Leake Street Graffiti Tunnel. Dedicated to graffiti, this 300-metre tunnel is a place when urban artists can legally go about their work, producing an ever-changing kaleidoscope of colourful and dramatic art on the walls and ceiling of the tunnel. The tunnel is located beneath Waterloo station and was made famous in 2008 when the legendary and anonymous artist Banksy held the Cans Festival in the tunnel. Urban artists from around the world were invited, after which the artistic legacy of Leake Street was secured. Dozens of street artists now work in the tunnel, ensuring that it is a constantly evolving area of living art. No surface is left untouched and it is always worth looking overhead too.

Nearby food and drink: A number of cafés and restaurants have sprung up along the length of the tunnel.

Nearby attractions: Leake Street is a short walk from the London Eye on the banks of the Thames, where there are a range of options for river cruises.

Little Venice

Photo spot: Warwick Avenue, West London.
what3words ref: folds.froth.fall

Direction: Facing northeast 35°NE

Camera zoom: x2

Best time of day: Early afternoon, with the sun behind.

Additional shot: Turn around at the photo spot to capture a photo of the Little Venice basin; see the next page.

 Selfie spot: From the middle of the bridge at the photo spot, you can capture a selfie with houseboats on either side.

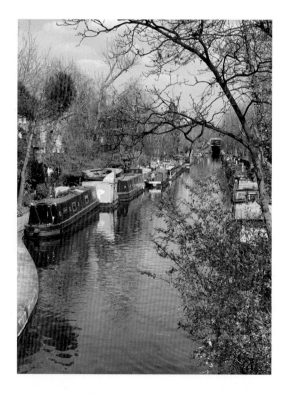

...cont'd

About this photo

Nearest Tube station: Warwick Avenue, exiting onto Warwick Avenue, at **marble.hips.closed**.

Getting there: Walk southeast along Warwick Avenue for 200 metres to get to the photo spot, on the bridge over Little Venice.

Photo fact: Standing on the bridge overlooking Little Venice, is it easy to forget that you are in the heart of one of the world's largest cities.

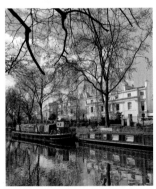

Little Venice is a basin of water formed by the Regent's Canal and the Paddington Arm of the Grand Union Canal. It is part of the canal network that, from the beginning of the 19th century, was used to transport goods around the country, and was also the source of creative ideas that emanated from the capital. Houseboats now populate the area around Little Venice, leading to it becoming a popular movie location, and it has been used for movies including *Jason Bourne*, the Beatles' *A Hard Day's Night*, and *Paddington 2*. Much of the towpath along the canal is for the private use of the houseboats' owners, but you can walk alongside the canal on the road.

Nearby food and drink: The banks of the canal are dotted with restaurants, cafés and pubs.

Nearby attractions: On the other side of the bridge at the photo spot is the Rembrandt Gardens, which provide an ideal spot for a rest and some quiet reflection.

Brick Lane

Photo spot: Spitalfields.
what3words ref: **plans.castle.entry**

Direction: Facing north 5°N

Camera zoom: x1

Best time of day: Morning, with the sun behind.

Additional shot: The chimney of the now-closed Truman Brewery (see the next page), is a good photo opportunity about halfway along the Lane.

Selfie spot: One of the things that Brick Lane is well known for is the numerous colourful murals on its buildings, and these offer excellent selfie opportunities.

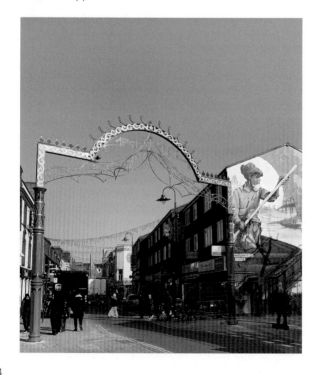

...cont'd

About this photo

Nearest Tube station: Aldgate East, exiting left onto Whitechapel High Street, at **filled.ankle.vital**.

Getting there: Walk 170 metres east along Whitechapel High Street and turn left into Osborn Street, at **torch.after.tennis**. Continue 200 metres north to get to the photo spot.

Photo fact: London has a long history of welcoming immigrants to the city and this has contributed greatly to the culture, vibrancy and diversity of the country's capital. One area that has been shaped by communities from around the world is Spitalfields, which for centuries has become home to – among others – the French Huguenots fleeing religious persecution in France, Jews, Russians and – most recently – Bangladeshis. Nowhere is this diversity more apparent than in Brick Lane (known locally as just "the Lane"). This was originally an area outside the city boundaries, near to the Augustinian priory of St. Mary Spital, from where the area takes its name. Brick Lane itself gets its name from the brick kilns that were brought to the area by early Flemish settlers. Brick Lane has always displayed characteristics of those who settled there: it became the centre of the silk-weaving industry with the arrival of the Huguenots; it then had a strong Jewish influence and now has a significant element of southeast Asia with the Bangladeshi community. Brick Lane is also famous for its market and has a strong brewing tradition, which can still be seen with the Truman Brewery, and although it closed in the 1980s, the brewery's dominant chimney can still be seen halfway along the Lane.

Nearby food and drink: Brick Lane is home to some of the best curry restaurants in London, and almost any of them are worth a try.

Nearby attractions: Christ Church Spitalfields at nearby Commercial Street, at **sample.bands. vanish**, is an imposing structure that has a rich history of its own; see page 203 for details.

Cutty Sark

Photo spot: King William Walk, Greenwich.
what3words ref: **pine.shark.times**

Direction: Facing west 290°W

Camera zoom: x1

Best time of day: Morning, with the sun to the left.

Additional shot: The Cutty Sark figurehead at the front of the ship makes for a good close-up photo. The Royal Museums Greenwich (included with entry to the Cutty Sark) also has the world's largest collection of ships' figureheads.

 Selfie spot: The deck of the Cutty Sark is an excellent location to capture a selfie with the ship's impressive masts in the background.

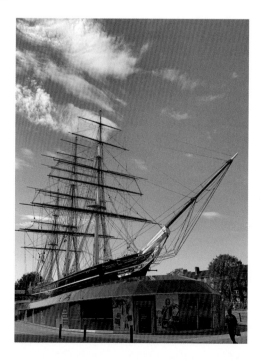

...cont'd

About this photo

Nearest Tube station: Cutty Sark for Maritime Greenwich (Docklands Light Railway – DLR – from Bank Tube station). Journey time 20 minutes.

Getting there: From the Docklands Light Railway station, exit onto Greenwich Church Street, at **sunk.race.toys**, and walk north for 100 metres to get to the photo spot.

Photo fact: Historically the River Thames has been a main route for trade, and in the 1850s Hay's Wharf was built near Tower Bridge to accommodate the boom in seagoing trade, with one of the main cargoes being tea, which was delivered in the impressive tea-clipper ships from India and China. One of the most famous of these was the Cutty Sark, named after a form of nightwear worn by one of the characters in the poem *Tam O'Shanter* by Robert Burns. The Cutty Sark was one of the last tea clippers to be built, but one of the finest. It was built on the River Clyde in Scotland, before it was brought to London in 1870. One of the trademarks of the tea clippers was their tall, imposing masts and the Cutty Sark is no different, with the main mast being 46.6 metres (153 feet) high. One of the aims of the builders of the Cutty Sark was to make it the fastest ship of its time, which was achieved during a voyage between Australia and England. The opening of the Suez Canal in the second half of the 19th century and the advent of steam ships began to spell the end of the tea clippers, so the Cutty Sark had to find a new cargo to transport and turned to coal and also wool. In 1954 the Cutty Sark was brought to its current location in a dry dock in Greenwich.

Nearby food and drink: The Cutty Sark Café, located on the lower deck of the ship, offers sandwiches, cakes and afternoon tea.

Nearby attractions: Next to the Cutty Sark, at **chief.wizard.stone**, is a statue of Sir Walter Raleigh, one of England's great seafaring heroes.

The Painted Hall

Photo spot: Old Royal Naval College, Greenwich.
what3words ref: **crisp.home.spoken**

Direction: Any. Low benches are available in the Painted Hall so that you can lie down and view the ceiling.

Camera zoom: x1

Best time of day: Any; indoors.

Additional shot: The Painted Hall ceiling provides numerous opportunities for close-up shots of individuals in the paintings (an audio guide is provided at the entrance to the Painted Hall, which explains some of the paintings).

 Selfie spot: From the steps leading to the Painted Hall it is possible to capture a selfie with much of the ceiling in the shot.

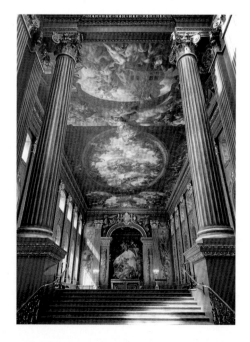

...cont'd

About this photo

Nearest Tube station: Cutty Sark for Maritime Greenwich (Docklands Light Railway – DLR – from Bank Tube station). Journey time 20 minutes.

Getting there: From the photo spot for the Cutty Sark (see page 136), walk south along King William Walk and turn left into College Way, at **toxic.late.washed**. Walk 250 metres northeast along College Way to get to the Old Royal Naval College. There is a sign for the entrance to the Painted Hall.

Photo fact: Although London has more than its fair share of art and culture, it is still something of a surprise to find a painted ceiling of such stunning quality that it is known as "Britain's Sistine Chapel". It is located in the Old Royal Naval College in Greenwich, next to the Cutty Sark, and it is an exceptional example of Italian Baroque art. The entire Painted Hall is an art-lovers delight, but it is the ceiling that demands special attention. The Painted Hall was painted by the artist Sir James Thornhill (1675-1734), and it took him 19 years to plan and paint it, completing it in 1726. It contains over 200 characters, including contemporary and historical figures, and also mythological ones. The Painted Hall has been used for several major events, the most notable being when Lord Horatio Nelson lay in state there in January 1806, following his death in 1805 at the Battle of Trafalgar. As a result of his efforts, Thornhill was the first English artist to be knighted, in 1720. The Painted Hall was restored in the 21st century and reopened in 2019, with the paintings fully restored to their former glory.

Nearby food and drink: There is a café in the Old Royal Naval College, at the entrance to the Painted Hall, and in the summer there are also pop-up stalls in the grounds.

Nearby attractions: Within the Old Royal Naval College, and included with the entry to the Painted Hall, is a Victorian skittle alley where you can test your bowling skills.

Kynance Mews

Photo spot: Kensington.
what3words ref: sweat.reform.tables

Direction: Facing west 280°W

Camera zoom: x1

Best time of day: Morning, with the sun to the left.

Additional shot: The arched entrance to Kynance Mews, at **laser.pink.across**, is bedecked with colourful flowers in the spring and summer, making for attractive photos.

Selfie spot: The residences in Kynance Mews are private homes, so be careful not to disturb people when taking selfies in the mews.

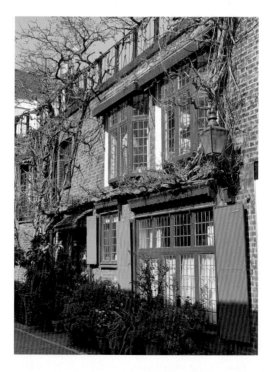

...cont'd

About this photo

Nearest Tube station: Gloucester Road. Exit the Tube station onto Gloucester Road, turning left at **daisy.vision.upper**.

Getting there: Walk north along Gloucester Road for 350 metres, crossing Cromwell Road, Southwell Gardens and Cornwall Gardens (twice). Turn left into Kynance Mews at **secure.baking.resort** to reach the photo spot.

Photo fact: Located in some of the most exclusive areas of London, the numerous mews areas are not only excellent photographic spots in the city but also boast some of the most expensive real estate. Mews housing was built in the 18th and 19th centuries and was originally designed as stables for horses, with accommodation for servants above it. During the 1960s their popularity as residential housing grew, as it was recognised that they were ideally hidden away from hectic city life while still being in the heart of the city. Since then their popularity has grown and grown. Different mews have their own characteristics, many of them with decorative flower displays, but they all have the traditional – and now very exclusive – mews housing. Locations like Kynance Mews are increasingly popular with Instagrammers looking to capture photos for their social-media accounts. Due to its photogenic properties, Kynance Mews has been used as the location for several movies over the years, including *Who Dares Wins* and *The Big Sleep*. The writer Bruce Chatwin is one of the well-known people who have lived in Kynance Mews.

Nearby food and drink: Da Mario Kensington is a friendly Italian restaurant and one of the nearest food outlets to Kynance Mews.

Nearby attractions: The Royal Albert Hall is a short walk from Kynance Mews; see pages 88-89 for details.

Platform 9¾

Photo spot: King's Cross station.
what3words ref: motor.record.drops

Direction: Facing southeast 142°SE

Camera zoom: x2

Best time of day: Any; indoors.

Additional shot: The exterior of King's Cross station itself is well worth a photo, at **eagles.discouraged.types**.

 Selfie spot: No self-respecting *Harry Potter* fan can leave King's Cross station without capturing a selfie with this iconic creation.

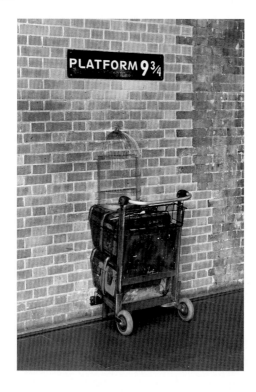

...cont'd

About this photo

Nearest Tube station: King's Cross St Pancras.

Getting there: From the Tube station, walk to the main concourse of King's Cross station and walk north for approximately 100 metres to reach the photo spot.

Photo fact: Fans of the *Harry Potter* books by J. K. Rowling seem to cite an increasing number of locations that claim to be the inspiration for some element of the books or another. However, one that has does have a genuine link to the books is Platform 9¾ at King's Cross station. This is where the students at Hogwarts School of Witchcraft and Wizardry disappear through the wall, to reach the Hogwarts Express to take them to the school. Obviously, this does not exist in real life (or does it?), but in the spirit of imagination, King's Cross has dedicated a corner of the station to its interpretation of this wizardly mode of transport, complete with half of a luggage trolley, as it makes its way to the Hogwarts Express. It is free to take your own photo with the luggage trolley embedded in the wall (or a professional photo can be taken by a photographer in the shop next door) but there can be a long queue at busy times, such as school holidays.

Nearby food and drink: While there are numerous restaurants, pubs and takeaways in King's Cross station, a better option is the range of establishments that lie outside the station, around the square, at **motion.went.achieving**.

Nearby attractions: Next to Platform 9¾ is the Harry Potter Shop at Platform 9¾, for any fans wanting to stock up on merchandise.

Paddington Bear Statue

Photo spot: Paddington station.
what3words ref: **play.forgot.clear**

Direction: Facing northwest 1°NW

Camera zoom: x2

Best time of day: Any; indoors.

Additional shot: There is another statue of Paddington Bear, on a bench in Leicester Square, at **trio.plays.being**.

Selfie spot: Who wouldn't want a selfie with one of the world's favourite literary bears?

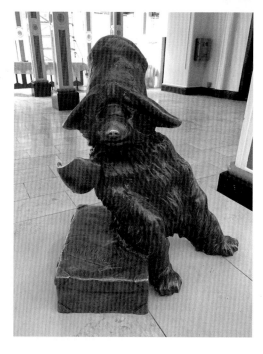

...cont'd

About this photo

Nearest Tube station: Paddington.

Getting there: From Paddington Tube station, follow the signs for the railway station, remaining indoors. From the concourse of Paddington railway station, head northwest along Platform 1 for approximately 200 metres to get to the photo spot (although at times the statue can be moved).

Photo fact: One of the best-known railway stations in London has been made famous by a small bear from Peru, with a liking for marmalade sandwiches. Paddington Bear, created by Michael Bond (1926-2017), first appeared in print in 1958 in *A Bear called Paddington*, and he has remained a firm favourite with children – and adults – ever since. Paddington arrives at the eponymous railway station, from darkest Peru, with a sign around his neck saying, "Please look after this bear, thank you". The books then follow his adventures in London after he is taken in by the Brown family. Paddington is a kindly soul, although if he thinks anyone is being impolite he treats them to his notoriously disconcerting "hard stare". The Paddington books number over 70 and have sold over 30 million copies, and been translated into 30 languages. There have also been two highly successful movie versions of Paddington, with Ben Whishaw being the voice of the much-loved bear.

Nearby food and drink: There are several food and drink outlets in Paddington station, although Paddington Bear himself may not approve, as none of them serves his favourite marmalade sandwiches.

Nearby attractions: Further along the platform from Paddington Bear is a more sombre statue, dedicated to the men and women of the Great Western Railway who lost their lives fighting for their country during the two world wars.

Miscellaneous Details

While it can be great to capture photos of iconic and interesting sites around a city, there are always hidden photographic gems that you will stumble across as you go around different locations. The important thing is to keep a lookout for miscellaneous photo opportunities, as well as the traditional ones. Some areas to keep an eye out for are:

- **Details of buildings**. These help to convey the character of buildings, rather than just their overall appearance. This can cover a multitude of elements: windows, door handles, artwork, tiles and stone structures.

- **The quirky and the quaint**. Cities are filled with weird and wonderful photo opportunities: it's just a question of noticing them. This can be done by spending a little bit of time looking around your surroundings, rather than just rushing from one attraction to another.

- **Tube-station artwork**. Many of London's Tube stations have colourful and artistic designs on their walls, so it is worth stopping – when possible and safe to do so – to capture some of these opportunities.

6 Jubilee Loop Walk

Because of its size, fitting everything in on your London sightseeing wish list can be a daunting prospect. However, the Jubilee Loop Walk offers an excellent way to see several of London's top sights, while also enjoying the not inconsiderable charms of St. James's Park.

The Jubilee Loop Walk is part of a larger network of walks around London, known as the Jubilee Walkway. The walk starts in Trafalgar Square and follows a route where you can see Buckingham Palace, The Mall, Parliament Square, Big Ben, and Horse Guards Parade.

The Jubilee Loop Walk is an excellent way to see some of the iconic locations within London, and also get a good feel for this central area of the city so that you can orientate yourself for other locations too.

St. James's Park is also a significant element of the Jubilee Loop Walk – this is a picturesque park that contains some interesting features of its own. It is also ideal for a picnic while on the walk.

Jubilee Loop Walk Introduction

This walk is an excellent way to see as many of London's top sights as possible, during a relatively short walk. The walk takes in sights including Buckingham Palace, Big Ben, Westminster Abbey, and Trafalgar Square.

Distance: 3.5 km. **Approx. number of steps**: 5,250.

Walk note – The Jubilee Walkway

The Jubilee Loop Walk is just one part of a larger group of London walks, known as the Jubilee Walkway. This has evolved from the Silver Jubilee Walkway, which was opened for Queen Elizabeth II's Silver Jubilee in 1977, and was renamed the Jubilee Walkway in 2002 for the Queen's Golden Jubilee. The Jubilee Walkway includes five separate circular walks of varying lengths, covering many of London's top sights. The walks are all relatively short, with the longest one being approximately 10 km (6 miles). The five Jubilee Walkway walks are: the Western Loop, the Eastern Loop, the City Loop, the Camden Loop, and the Jubilee Loop. Each walk is punctuated by discs that point in the direction of travel, and gold discs that indicate items of interest on the walk. For more information about the Jubilee Walkway, see the *Travel for London* website at **tfl.gov.uk/modes/walking/ jubilee-walkway**

Starting Point

The walk starts at Trafalgar Square, at the Jubilee Walkway panel on the south side of the square, at **frame.ranks.modest**, at the foot of Nelson's Column. The nearest Tube station is Charing Cross station. Turn west out of the Tube station and walk along Strand until you reach Trafalgar Square.

Walk Details

1 From the starting point, at the foot of Nelson's Column (see pages 74-75 for details), head south and cross the road (Trafalgar Square) at **spite.worth.prep**, joining The Mall at **heats.beans.export**

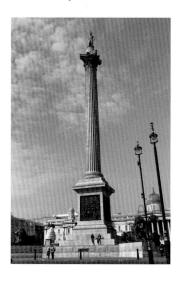

2 Walk southwest along The Mall, passing through Admiralty Arch at **indeed.wipe.reader**

3 Continue along The Mall, passing the Captain James Cook Statue on the other side of The Mall at **broke.jumpy.breath**

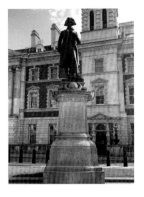

4 Walk 200 metres from Admiralty Arch, passing the Institute of Contemporary Arts on the right-hand side, and cross The Mall at **tame.plug.round**, opposite the Duke of York statue at **latter.rate.organ**

Historical note – Grand Old Duke of York

The Duke of York statue, set back from The Mall, up some low steps, was installed in 1834 to commemorate George III's son, Prince Frederick William (1763-1827), who had the title of the Duke of York and Albany. He was a successful Commander-in-Chief of the British Army although, due to events in his private life, he died in debt, and much of the money for the statue was raised by soldiers who had served for him. It is thought that he is the inspiration for the nursery rhyme, *The Grand Old Duke of York*.

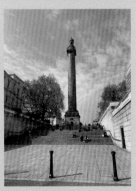

5 St. James's Park is on your left-hand side as you face southwest on The Mall

Refreshment stop – St. James's Park

St. James's Park is an excellent spot for a picnic (weather permitting) during the walk.

Walk detour – The Diana, Princess of Wales Memorial Walk

Approximately halfway down The Mall at **trades.grants.roofs** is an option to take a detour onto the Diana, Princess of Wales Memorial Walk. Diana married Prince Charles in 1981 and they divorced in 1996. When she died in a car accident in Paris in 1997 there was

huge outpouring of emotion by many people in the country. The walk in Diana's memory is 10 kilometres long and takes in locations in four of the city's Royal Parks. Full details can be found at **royalparks.org.uk**

6 Continue along The Mall, where Buckingham Palace is visible at the southwest end. Take the opportunity to take some photos of both these iconic London settings as you walk along The Mall

Historical note – Queen Victoria

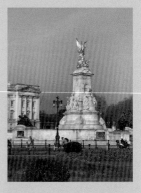

The statue in front of Buckingham Palace in Step 7 on the next page is the Victoria Memorial to Queen Victoria (1819-1901), now Britain's second-longest-reigning monarch, having since been surpassed by Queen Elizabeth II. Queen Victoria reigned for 63 years, over what become known as the Victorian era of British history, a period of significant political and social change. At the time of her birth, Victoria was only fifth in line to the throne but, due a series of royal deaths, she acceded to the throne shortly after her 18th birthday, in 1837. Victoria married Prince Albert of Saxe-Coburg and Gotha in 1840 and the marriage was a happy one that produced nine children. Albert died from typhoid fever in 1861 – this left Victoria devastated, and greatly influenced much of the rest of her life. Victoria oversaw 20 different government administrations during her time on the throne, including William Gladstone (four times) and Benjamin Disraeli (twice). Significant events during her reign included the completion of the abolition of slavery, the Irish Potato Famine, the Crimea War, the opening of the London Underground, compulsory education for children under the age of 10, and India being incorporated into the British Empire, when Victoria added Empress of India to her titles. Queen Victoria died on 22 January 1901, leaving a country that had been transformed during her reign.

7 Continue approximately 700 metres along The Mall to Buckingham Palace, and the photo spot for the top sights photo on page 58

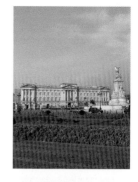

8 Keeping St. James's Park on your left-hand side, walk past Buckingham Palace, along Spur Road, joining Birdcage Walk at **splash.sentences. hoping**

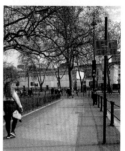

Walk detour – St. James's Park Playground

For anyone with children, St. James's Park Playground can provide some light relief from a busy day's sightseeing. Enter St. James's Park at the start of Birdcage Walk at **speeds.zips.strike**. Turn right at the fork in the path at **poetic.wizard.grab**, and the playground is 40 metres on the left-hand side. There is also a small refreshment kiosk at the playground.

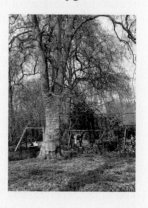

9 Walk east along Birdcage Walk for 600 metres, crossing Horse Guards Road, where it joins Great George Street at **play.mute.hints**

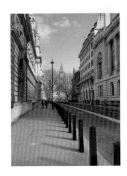

Historical note – Arthur Sullivan

At the start of Birdcage Walk on the right-hand side (heading east) is Sullivan's Plaque at **nature.speak.sheep**. This commemorates the life of Arthur Sullivan, an Australian soldier who was awarded the Victoria Cross for bravery during World War I, when he

rescued four members of his platoon who had fallen into a river when under attack from the Bolsheviks in northern Russia. Sullivan was a popular figure when he returned to Australia, and his undemonstrative personality endeared him to the public even more. In 1937 Sullivan was chosen as part of the Australian delegation to attend the coronation of King George VI in London. Unfortunately, during his time in London, Sullivan suffered a fall while he was walking back to his accommodation in the evening and died shortly afterwards. Sullivan's Plaque was put in place in 1946, and should not be confused with Sullivan's Statue, which is a statue in honour of the British composer, also Arthur, who was one half of the famous musical team of Gilbert and Sullivan, located in Victoria Embankment Gardens at **agenda.chins.costs**.

 10 Follow Great George Street for 225 metres, passing the Churchill War Rooms, part of the Imperial War Museums (IWM), on the left-hand side, reaching Parliament Square at **loose.bunks.people**

Walk detour – Imperial War Museums

Established in 1917 while World War I was at its height, the Imperial War Museums are intended as a record of war and people's experiences during and after it. There are five museums in total: the IWM London on Lambeth Road at **rubble.points.frogs**; the Churchill War Rooms along Great George Street (entrance from the Clive Steps on King Charles Street at **puppy.fork.send**); one on HMS Belfast on the Thames, near to Tower Bridge at **sleepy.many.pines**; and further ones in Manchester and Duxford (in Cambridgeshire – Europe's largest air museum).

11 Cross into Parliament Square Garden, at the crossing in Step 10, entering Parliament Square Garden at **angle. snap.fishery**

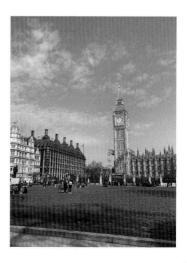

Photo stop – Parliament Square Statues

Parliament Square Garden is home to numerous statues of famous world figures through history, including Winston Churchill, David Lloyd George, Benjamin Disraeli, Sir Robert Peel, Nelson Mandela, Abraham Lincoln, Mahatma Gandhi, and Millicent Fawcett (see below).

Historical note – Millicent Fawcett

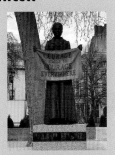

Although perhaps not as widely known as some of her neighbouring statues in Parliament Square Garden, Millicent Fawcett (1847-1929) is deserving of an equally enduring historical legacy. Known as a Suffragist, Fawcett was a major figure in achieving the vote for women, although she advocated this through political and peaceful means, rather than the – at times – more militant Suffragette movement. From 1897 Fawcett was the president of the National Union of Women's Suffrage Societies and worked tirelessly to achieve the vote for women, which was partially achieved with the Representation of the People Act in 1918, which entitled women over 30 to vote, with certain conditions. It was not until 1928 and the Representation of the People (Equal Franchise) Act 1928 that women achieved full electoral equality.

12 Parliament Square is the perfect location to capture photos of some of London's most iconic landmarks: see pages 62-63 for details about photos of Big Ben from Parliament Square, and see pages 66-67 for details about photos of Westminster Abbey

13 From Parliament Square, retrace your steps to the junction of Great George Street and Horse Guards Road, in Step 9 on page 154 at **play.mute.hints**, turning right into Horse Guards Road

14 Walk north along Horse Guards Road for 350 metres, to reach Horse Guards Parade on the right-hand side at **hope.mint.ripe**, and opposite the Guards Memorial at **single.social.exile**. This is the location for the annual Trooping the Colour

Historical note – Trooping the Colour

Trooping the Colour is very much a British institution that takes place in Horse Guards Parade every June, to mark the official birthday of the British monarch. (The reason the monarch has an actual birthday and an official one dates back to 1748 and George II, who was born in November 1683. He wanted a large celebration 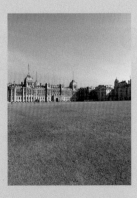 for his birthday, but one that was not blighted by the British winter weather, so he decided to incorporate it into Trooping the Colour.) Dating back to the time of Charles II, the idea of Trooping the Colour is that the colours of a regiment are "trooped" in front of the regiment so that they can recognise them in battle. The modern ceremony consists of 1,400 parading soldiers, 200 horses and 400 musicians, who present themselves for the monarch's inspection.

Walk detour – Duck Island

On the way to Horse Guards Parade, cross to the left-hand side and enter St. James's Park at **hands.speeds.ruled**. Turn first right and walk 90 metres to reach the entrance to Duck Island. This is a small nature reserve, containing some of the park's bird collection, although at the time of printing it is closed to the public,

but can still be viewed from the path.

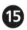 **15** From Horse Guards Parade, return to Horse Guards Road and enter St. James's Park, at the Guards Memorial at **bonds.amused.supply**. Walk around the memorial, which is in memory of the Guardsmen who died in World War I, and take some time to enjoy the surroundings of the park

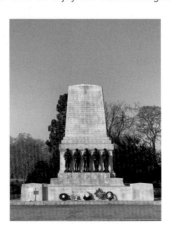

Refreshment stop – St. James's Café

thus.city.copper

From the entry point to St. James's Park in Step 15 on the previous page, walk around the Guards Memorial and turn left onto the path. Walk 150 metres to reach St. James's Café. This is a light and airy café that offers indoor and outdoor options for a relaxing snack or meal while enjoying views of the park.

16 From St. James's Café (see above) take the path at **chase.clip.chart**

17 Walk north along the path for 150 metres, exiting the path onto The Mall

Historical note – South African Royal Artillery Memorial

This impressive memorial, next to the entrance to St. James's Park at **invite.called.client**, is in honour of the members of the Royal Artillery killed in the Boer War (1899-1902) in South Africa. The winged figure on the memorial depicts Peace subduing War, depicted by the horse.

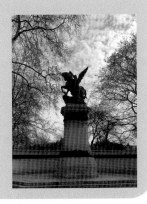

18 Walk back along The Mall and underneath Admiralty Arch to return to Trafalgar Square and the end of the walk

Jubilee Loop Walk Locations

Some more London Jubilee Loop Walk locations to track down are:

- **Canada Gate** at **clean.repay.pokers**. Next to Buckingham Palace and at the entrance to Green Park, this ornate gate was a gift from Canada and was installed in 1911 as a memorial to Queen Victoria.

- **King George VI and Queen Elizabeth Memorial** at **limes.slides.poetic**. One of the many monuments on The Mall, this one consists of two statues: King George VI and his consort Queen Elizabeth the Queen Mother, who died in 2002, aged 101.

- **St. James's Palace** at **famous.lives.liner**. Situated off The Mall and built originally by Henry VIII, St. James's Palace remains an official residence of the monarch, although it is not occupied by them. It nevertheless retains important ceremonial significance and is a major component of royal palaces in the country.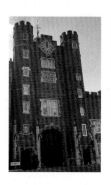

- **The Turf Club** at **metro.trips.frogs**. The Turf Club is a one of the many gentlemen's clubs in London, a very visible example of the British class system, as they are populated largely by the upper classes of society. The building in which the Turf Club is located, at 5 Carlton House Terrace, was designed by the renowned architect John Nash, who also designed Buckingham Palace and Marble Arch.

- **Wellington Barracks** at **verse.oval.order**. Located near to Buckingham Palace, on Petty France Road, Wellington Barracks houses the Foot Guards battalion, which has the responsibility of protecting the royal family, hence its proximity to Buckingham Palace.

7 Thames Walk

The River Thames is not only an iconic London landmark in its own right; some of the city's best-known sights can also be seen from its banks.

This walk starts at Vauxhall Bridge and follows the Thames eastwards, crossing three of its bridges before finishing at Tower Bridge, in the shadow of the Tower of London. On the way, sights including Big Ben, the Houses of Parliament, the London Eye, and Shakespeare's Globe can be viewed.

The walk also takes in some of the less well-known sights of London, but they are noteworthy in their own right. These include: the Boudiccan Rebellion statue, celebrating the Queen who fought the invading Romans; the relaxing Whitehall Gardens; Cleopatra's Needle and the extraordinary story of how it came to be at its location on the banks of the Thames; and the sobering National Covid Memorial Wall for those who died during the Covid-19 pandemic. The walk also shows where you can take river cruises to get even closer to this integral part of London life.

Thames Walk Introduction

This walk stretches from Vauxhall Bridge at Pimlico to Tower Bridge further east and gives an excellent sense of how the River Thames interacts with the surrounding city.

Distance: 6.5 km. **Approx. number of steps**: 9,750.

Walk note – The Thames Walk

The history and character of London is inextricably linked to the river that winds its way through the city, in a snake-like pattern. Taking its name from the pre-Celtic for "dark river" (tamasa), the River Thames has contributed to the development of London since the Romans settled there in AD 43, and it has been involved with the city's commerce through the centuries. The 18th century saw one of the biggest expansions of trade via the Thames, with dozens of docks and wharves being constructed to accommodate the vast amount of sea trade from around the world. Another surge occurred at the beginning of the 19th century, with the creation of the West India Dock Company. The amount of business coming through the Thames also contributed, either directly or indirectly, to employment for large numbers of Londoners. However, this largely came to an end in the 1960s with the introduction of container ships, which rendered many of the London docks redundant. Despite this, the redevelopment of the Docklands area in the 1980s shows that the Thames, and the areas around it, still has a vital role to play in the city's ongoing success. In addition to the commercial development of London, the Thames has always attracted artists to its banks, with three of the most notable being Canaletto, Turner, and Whistler.

Starting Point

The Thames Walk starts at Vauxhall Bridge. Pimlico is the nearest Tube station. From the Tube station, walk north along Drummond Gate to reach Vauxhall Bridge Road, at **stray.sooner.wallet**. Turn right onto Vauxhall Bridge Road and walk 300 metres to reach Vauxhall Bridge, at **pirate.people.stand**.

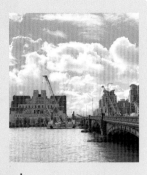

Walk Details

1 From Vauxhall Bridge, walk along the north side of the Thames, along Millbank, with the Thames on your right-hand side

Historical note – MI6 building

Considering that it houses international spies, the M16 building at Vauxhall is surprisingly conspicuous as it looms over the River Thames. Its full name is the Secret Intelligence Service (SIS) Building, and it is the headquarters of the UK's foreign intelligence service. The use of the building has

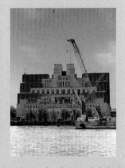

never been much of a secret, even though the activities within it are classified. Although famously blown up in the James Bond movie *Skyfall*, the real-life MI6 building stands firm in protecting the nation's security.

2 Continue north along Millbank for 775 metres, passing the Tate Britain, at **lunch.goad. places**, part of the group of art galleries that include the Tate Modern. The Tate Britain, located on Millbank, houses an

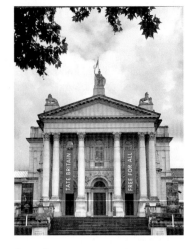

impressive array of art, from 1545 to the present day, including the Turner Collection

3 Pass the MI5 building on the left-hand side of Millbank, at **tags.cliff. intend**, and turn right onto Lambeth Bridge, at **hardly. gather. remedy**

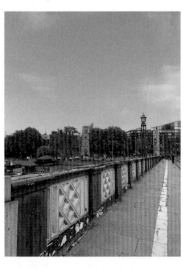

4 Cross Lambeth Bridge and turn left at the end, at **launch.shrimp.bliss**, into Lambeth Palace Road

5 Walk 150 metres along Lambeth Palace Road to reach Lambeth Palace, at **weeks.crass.fell**

Historical note – Lambeth Palace

Lambeth Palace is one of 11 Royal Palaces in London and it is the official London residence of the Archbishop of Canterbury. It is also one of the oldest Royal Palaces, being nearly 800 years old. Although it does not always receive the same amount of attention as Buckingham Palace or Kensington Palace, Lambeth Palace is a building of considerable historical significance. One of its main features is an extensive historical library with valuable religious books and documents dating back several centuries.

6 From Lambeth Palace, retrace your steps to Lambeth Bridge and join the Albert Embankment path, at **stacks.fade.woes**

7 Walk along Albert Embankment path for 520 metres, with the Thames on your left-hand side, and pass the Houses of Parliament, to Westminster Bridge, at **ashes.scans. force**

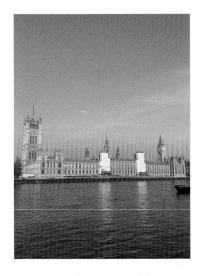

Walk note – Covid Memorial Wall

Running along the length of the section of Albert Embankment opposite the Houses of Parliament is the National Covid Memorial Wall. This is dedicated to everyone in the United Kingdom who died from Covid-19 during the pandemic.

The wall is covered with red hearts, with the names of people who have died within them.

8 Cross Westminster Bridge, heading towards Big Ben, and turn right at the end, towards Victoria Embankment, at **full.bells. thank**

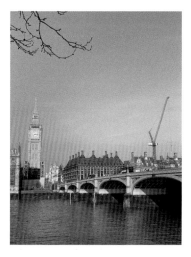

9 Walk past the Boudiccan Rebellion statue on the north side of Westminster Bridge and continue north along Victoria Embankment

Historical note – Boudiccan Rebellion Statue

London is a city that loves erecting statues to recognise notable people or events in history. One that relates to a distant historical event is the Boudiccan Rebellion statue, at **beard.left.pigs**.

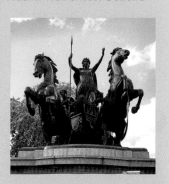

This commemorates the efforts of Queen Boudicca of Iceni, who led a rebellion in AD 61 against Roman invaders who had colonised the country. Boudicca was a formidable foe for the Romans, and it is claimed that she and her Celtic army killed 70,000 Roman soldiers and their supporters. Despite this, Boudicca lost her final battle and died shortly afterwards.

Walk detour – Cenotaph

Running parallel to Victoria Embankment, to the west, is Parliament Street, in Whitehall, which is the location for the Cenotaph, at **blur.stays.think**. Derived from the Greek for "empty tomb", the Cenotaph is the national war memorial for those British and Commonwealth soldiers who died in the two world

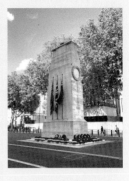

wars and subsequent conflicts. It is used for national acts of remembrance, particularly the National Service of Remembrance held in November each year on Remembrance Sunday to honour the war dead.

10 Walk along Victoria Embankment, passing the Battle of Britain Monument to the Royal Air Force and those who took part in this famous battle, at **expand. skills.gallons**

11 Continue past Whitehall Gardens on the left-hand side, at **noisy.farms.hints**. There are some benches here where you can take a break and enjoy the gardens (take care crossing Victoria Embankment)

 About 600 metres from Westminster Bridge, continue past the Golden Jubilee Bridges, at **puff.island.plant**

Walk note – Golden Jubilee Bridges

London has several famous and eye-catching bridges, and another one was added in 2002 to mark Queen Elizabeth II's 50th year on the throne. The Golden Jubilee Bridges are foot bridges that stretch along both sides of the Hungerford Bridge, which is a rail bridge, on the site where the original bridge was designed by 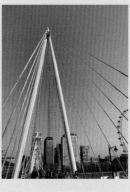 the world-famous engineer Isambard Kingdom Brunel in 1845. Despite numerous engineering challenges, the Golden Jubilee Bridges were completed successfully and have since won several architectural awards.

13 Continue along Victoria Embankment, with Victoria Embankment Gardens on the left-hand side, at **kind.epic.songs**

Refreshment stop – Embankment Café

Situated on Victoria Embankment, at **blows.living.trap**, this charming café has an outdoor seated area where you can enjoy a refreshment and also the attractive gardens that surround the café.

14 Walk 120 metres from the Victoria Embankment Gardens to reach Cleopatra's Needle, on the right-hand side, at **blunt.like.renew**

Historical note – Cleopatra's Needle

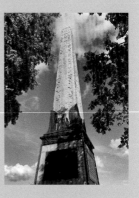

Having an Egyptian obelisk in the centre of London is perhaps not everyone's first association with the city, but the story of how it arrived in London is worthy of a visit to it alone. Relating to Alexandria, the royal city of Cleopatra, the obelisk was brought to England in 1878 to commemorate Wellington's victory at Waterloo over 50 years earlier. The obelisk was transported by sea, in a specially designed cigar-shaped ship to accommodate its size. In October 1877, dangerous seas in the Bay of Biscay led to the crew being rescued from the ship, although six people died in the process (their names now appear around the base of the obelisk). For five days the ship carrying the obelisk was adrift without a crew, but remarkably it remained afloat and was rescued. It arrived safely in London in January 1878, where it was met by cheering crowds.

15 From Cleopatra's Needle, walk northeast for 200 metres, passing under Waterloo Bridge, at **tennis.bets. waddle**

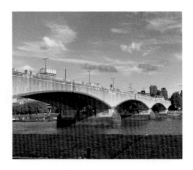

 Continue along Victoria Embankment for 900 metres to reach Blackfriars Bridge, at **plants.pipe.nation**

Walk note – River cruises

There are many options for seeing the sights of London, and one of these is to take a river cruise along the River Thames. Several of these depart from Victoria Embankment, on the north side of Westminster Bridge. Some of the cruises go as far as Kew, to the west, which is an excellent way to visit the exceptional Royal Botanic Gardens at Kew, at **money.forget.again**.

 On the way to Blackfriars Bridge, you pass the Middle Temple Gardens on the left-hand side, at **corn.farms.rats**

18 Cross over Blackfriars Bridge, where the River Fleet passes below, to the south side of the Thames, and turn left at **shield.limit.risk**

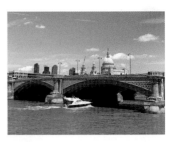

Historical note – River Fleet

Much of the history of London is based around water, with its location on the River Thames being a major factor in its commercial success. Another significant river is the River Fleet, London largest subterranean river. From Roman times the River Fleet was a major London river, but as the city developed it became a dumping ground for a variety of waste and was virtually an open sewer. Despite this, several wells were created along the River Fleet, many of which were claimed to have healing properties. After the Great Fire of London in 1666, Christopher Wren built a canal system on parts of the Fleet, but this was rendered inoperable by the amount of sewerage in the river. In the 18th and 19th centuries the Fleet was covered over and it now serves as a large underground sewer.

19 Continue east along Thames Path/Bankside, for 575 metres, past the Tate Modern, the Millennium Bridge, and Shakespeare's Globe to reach Southwark Bridge, at **head.dime.wisely**

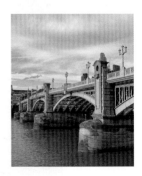

20 Walk under Southwark Bridge and Cannon Street Railway Bridge

21 Continue 350 metres to London Bridge, and past the Shard, walking under the bridge and turning left at **marker.round.meals** to reach The Queen's Walk, at **gains.heads.flank**. Continue for 400 metres to HMS Belfast, at **driven.glee.maker**

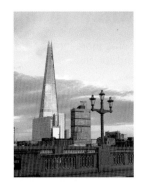

22 From HMS Belfast, continue 380 metres to reach Tower Bridge, at **chins.trades.pies**

Historical note – HMS Belfast

Now part of the Imperial War Museums, the HMS Belfast warship was launched for the Royal Navy in 1938. It saw much active service, including firing some of the first shots of the D-Day landings on 6 June 1944. In 1963, the HMS Belfast was retired from service and took up its current role as part of the Imperial War Museums in 1971.

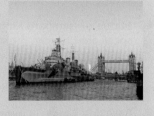

23 This is the finishing point of the walk. Cross Tower Bridge to the Tower of London and Tower Hill Tube station, at **successes.olive.pill**, or retrace your steps to London Bridge Tube station, at **riots.beans.sweep**

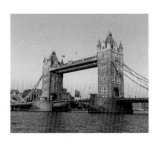

More Thames Walk Locations

Some more locations of interest on the Thames Walk to look out for are:

- **Sea Life Centre, London Aquarium**, at **shield. divisions.parts**. Located near to the London Eye, the London Aquarium features sharks, penguins, octopuses, rays, coral reef inhabitants, and rainforest species.

- **Statue of Samuel Plimsoll**, at **grand.sheets.weds**. Famous for inventing the Plimsoll Line to determine how much cargo ships could safely carry, Samuel Plimsoll (1824-98) was also a politician and social reformer.

- **Bronze Sphinx**, at **fancy.breath.bond**. Appropriately situated on either side of Cleopatra's Needle on the Victoria Embankment (although not linked to it).

- **Statue of Isambard Kingdom Brunel**, at **speak.shift.evenly**. The statue of the famous engineer (1806-59) sits on Victoria Embankment, recognizing Brunel's work in London, which included the Hungerford Bridge and the Thames Tunnel (with his father Marc).

- **Bankside Beach**, at **jumpy.found.bridge**. Beaches are few and far between in London, but there is a small one at Bankside, near to Shakespeare's Globe.

- **The Golden Hinde**, at **potato.wisely.smug**. This is a replica of the famous ship used by Sir Francis Drake (c.1540-96) to circumnavigate the globe from 1577 to 80. Drake is also remembered for his role in defeating the Spanish Armada in 1588 and preventing them from invading England and overthrowing Queen Elizabeth I.

8 Hyde Park Walk

The Hyde Park Walk can be a peaceful antidote to some of the more frantic activities in London, and after a short time in its wide open green spaces, it is possible to forget all about the teeming city life all around Hyde Park.

This walk not only takes in the majority of Hyde Park but also Kensington Gardens, which combines with Hyde Park to make one continuous green space.

The walk covers some of the main locations of Hyde Park, such as the Serpentine area of water that stretches between Hyde Park and Kensington Gardens, the peaceful Serenity statue, and the historic Speakers' Corner in the northeast corner of Hyde Park.

The walk also encompasses some of the picturesque areas of Hyde Park, such as the Rose Garden and the Serpentine Waterfall. Overall, the Hyde Park Walk is a great way to experience an attractive and relaxing corner of London, while getting to know some of its favourite features.

Hyde Park Walk Introduction

This walk creates a trail around Hyde Park and Kensington Gardens, taking in some of the sights of this extensive and relaxing park area.

Distance: 4.5 km. **Approx. number of steps**: 6,750.

Walk note – Hyde Park (and Kensington Gardens)

For a city with a reputation as a global centre of commerce and finance, and all of the trappings that go with that, London is blessed with some exceptional green spaces where you can quickly forget that you are in the heart of one of the world's busiest cities. One of these is Hyde Park, with another being the neighbouring Kensington Gardens (the two form one large green space, separated by a body of water between the two). Known as "the lungs of the city", Hyde Park is one of eight royal parks, covering 350 acres. Created by Henry VIII as a hunting ground, Hyde Park has had a varied history and has been used for activities as diverse as hay-making, the Great Exhibition of 1851, protests by the Suffragettes, and rock and classical concerts. It also contains a rich selection of flowers, plants and trees.

Starting Point

The walk starts at the Wellington Arch, at the southeast corner of Hyde Park, at **spite.goat.again**. The nearest Tube station is Hyde Park Corner. Cross Piccadilly, heading south, at **holly.vouch.petal**, and walk across the square to view the arch and reach the starting point.

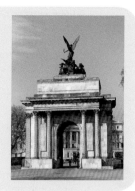

Walk Details

1 Walk through the Wellington Arch, heading west, and cross the road at the junction of Grosvenor Place and Piccadilly, at **error.seated.ears**, passing the Wellington statue at **tigers.second.leave**

Historical note – Duke of Wellington

Arthur Wellesley, 1st Duke of Wellington (1769-1852) is one of Britain's great military heroes, most famous for his victory over Napoleon and the French at the Battle of Waterloo in 1815. Wellington had numerous other military victories and he became famous for his defensive tactics that enabled him to defeat much larger forces, while minimising losses to his own troops. In addition to his military prowess, Wellington was also an effective politician, and he served twice as Prime Minister during the 19th century.

2 Walk north for 100 metres onto South Carriage Drive and enter Hyde Park at the Queen Elizabeth Gate, at **cone.juices.royal**

3 Walk south around the outer perimeter path, turning right onto the path heading west, at **limbs.shower.shelf**

4 After 70 metres, take the next path on the right, at **cattle.legs.ties**

5 Walk past the Boy and Dolphin Fountain, at **clip.vibe.game**. The Boy and Dolphin Fountain was created in 1862 by Alexander Munro, a friend of the author Lewis Carroll, and moved to Hyde Park in 1995

6 Continue along the path and walk through the Hyde Park Rose Garden, taking some time to enjoy the flowers and plants and also the tranquillity of the garden

7 Leave the Rose Garden, at **assist.quit.bind**, and continue west along the path for 200 metres. Walk across the grass to view the Hyde Park Holocaust Memorial, at **olive.loads.pokers**

8 Walk west from the Hyde Park Holocaust Memorial, onto the path at **lamp.noses.jumped**

Historical note – Hyde Park Holocaust Memorial

This small garden was Britain's first memorial to the victims of the Holocaust. It was created in 1983 and funded by the Board of British Jews. It consists of a number of small boulders, surrounded by birch trees.

9 The Serpentine Waterfall is to the west of the path, at **quarrel.taxi. cloak**

10 Walk south along the path, with the waterfall on your right-hand side. Turn right, at **grain.sleep.ticket** and, after 100 metres, take the next right, at **ramp.lung.jazzy**, and walk 50 metres to view the memorial to Queen Caroline, at **crust.hiding.damage**

Historical note – Queen Caroline

Queen Caroline (1683-1737) was the wife of King George II. She had a great love of Hyde Park, and neighbouring Kensington Gardens, and from 1726-30, she helped create the Serpentine in Hyde Park and Long Water in Kensington Gardens.

11 Retrace your steps to reach the path on the south side of the Serpentine, at **museum.chief.bond**

12 Walk 500 metres west to reach the Serpentine Lido area for open-air swimming, at **panels.allow.soup**

Refreshment stop – Serpentine Lido Café

There are several food and drink options throughout Hyde Park, and one of the most picturesque is the Serpentine Lido Café. There are tables inside and outside where you can enjoy a selection of meals and snacks, including fish and chips, burgers, salads and alcoholic or soft drinks.

13 Continue on the path past the café for 100 metres to reach the Serenity statue, at **cares.loser.snaps**

14 Walk around the right-hand (north) side of the Serenity statue and continue along the path, with the Serpentine on your right, crossing below the Serpentine Bridge, at **spends.dizzy.deeper**

Walk note – Serenity

This eye-catching bronze sculpture was designed by the sculptor Simon Gudgeon and was installed in 2009. It is inspired by the Egyptian goddess of nature. There are benches around the statue, for some peaceful contemplation.

Walk detour – Kensington Gardens

Although the park to the west of Hyde Park seems like the same area, it is in fact Kensington Gardens, which are to the west of the Serpentine and the Long Water. Kensington Gardens are home to Kensington Palace (see pages 84-85 for details) and the Albert Memorial (see pages 86-87 for details).

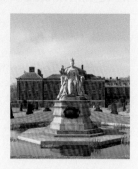

15 Passing the Serpentine Bridge, the Serpentine becomes the Long Water. Continue along the path for 400 metres to reach the Peter Pan statue, at **live.today.badge**

Walk note – Peter Pan Statue

Made famous by the author J. M. Barrie, the story of *Peter Pan*, the boy who never grew up, is part of many people's childhood. This bronze statue of the eponymous hero was installed in secret in 1912, and it now has an interactive feature whereby you can swipe your smartphone on the nearby plaque to hear Peter talking.

16 Walk a further 300 metres north along the path to reach the Italian Gardens, at **woven.bought.shiny**

17 After viewing the Italian Gardens, walk along the path on the east side of The Long Water, at **nets.large.other**

18 Continue along the path for 440 metres, with the Long Water on your right-hand side, to reach the Henry Moore Arch, at **dreams.doctor.combining**

Walk note – Henry Moore Arch

Henry Moore (1898-1986) was one of Britain's best-known artists and sculptors, and his fame has spread around the globe. Standing at six foot tall, the arch was originally installed in 1980, weighing 37 tons. This contributed to its structural instability, and in 1996 it was dismantled. In 2010 a successful restoration program was undertaken and the sculpture was reinstalled in 2012.

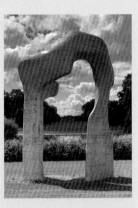

19 From the Henry Moore Arch, walk 100 metres south along the path to join West Carriage Drive at the northern end of the Serpentine Bridge, at **chin.badly.files**

20 Continue 50 metres north along West Carriage Drive, walking on the right-hand side

Walk note – Hudson Memorial

The Hudson Memorial Bird Sanctuary, at **kept.urgent.flying**, is a carved stone memorial to the memory of William Hudson (1841-1922), who was a naturalist that played a prominent role in the establishment of the Royal Society for the Protection of Birds (RSPB).

21 Turn right onto the path, at **trains.drift.gift**, and continue for 650 metres to reach the Reformers' Tree, at **stress.latter.lovely** (the path becomes Emma FitzGerald Walk at **desks.sings.sings**)

Historical note – Reformers' Tree

The Reformers' Tree is a symbolic mosaic, commemorating the location of what was once an actual tree. It was used as a rallying point for the campaign to give all adult men the right to vote (see Speakers' Corner on the next page). During one of the group's protests, the tree was burnt down and its stump became a symbolic meeting spot.

22 From the Reformers' Tree, join the Nicholas Hemingway Walk at **desks.double.door**

23 Walk north along Nicholas Hemingway Walk for 170 metres, turning right onto the path at **silks.holly.stews**

24 Continue along this path for 100 metres to reach Speakers' Corner, at **test.rich.fallen**

Historical note – Speakers' Corner

Speakers' Corner has been a bastion of free speech in London for over 150 years, and it continues to be so to this day. Its existence dates back to 1866 when there were riots in this corner of Hyde Park in support of the extension of voting rights. As a result, an Act of Parliament was passed in 1872, conferring the right to meet and speak freely at this location. Over the years, the likes of Karl Marx, Vladimir Lenin and George Orwell have exercised their right to free speech at Speakers' Corner.

25 From Speakers' Corner, walk east along the path at **organs.case.behind** and turn left into Park Lane at **king.global.call**. Walk 250 metres north along Park Lane to reach the end of the walk at Marble Arch, at **cried.tapes.media**. (This is also the starting point for the *Monopoly* Walk; see pages 187-198). Marble Arch Tube station is next to Marble Arch, at **libraries.stop.score**

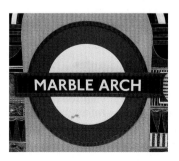

More Hyde Park Locations

Some more Hyde Park and Kensington Gardens locations to track down are:

- **The LookOut**, at **sing.party.crowd**. This is an eco-friendly building that promotes the natural world, and offers a range of family and wellbeing activities.

- **The Allotment in Kensington Gardens**, at **coffee.vanish.unrealistic**, is exactly as the name suggests: a garden allotment in the heart of the city. Visitors are encouraged to have a look around, view the produce being grown, and even pick up some gardening tips and hints.

- **Queen Caroline's Temple**, at **diner.lasts.organs**. Another structure dedicated to Queen Caroline, who was instrumental in the design and layout of Hyde Park and Kensington Gardens. Situated to the east of the Long Water, this is an impressive summer-house retreat, designed by Queen Caroline herself.

- **Serpentine Gallery**, at **forum.woes.design**. An art gallery in Kensington Gardens, with free entry to its temporary art exhibitions. The Serpentine North Gallery is located across the Serpentine Bridge, in Hyde Park, at **noises.toys.brings**.

- **Princess Diana Memorial Fountain**, at **figure.linked.still**. Situated next to the Serenity statue, this is one of several memorials in Hyde Park and Kensington Gardens to Diana, Princess of Wales, who died in a traffic accident in 1997. It consists of 545 pieces of Cornish granite, and aims to represent Diana's values in life. The water for the fountain is taken from the London water table and is constantly refreshed.

- **7 July Memorial**, at **villa.toast.grid**. A memorial of 52 steel pillars, representing the 52 people killed in terrorist attacks in London on 7 July 2005. It is located in the eastern corner of Hyde Park.

9 Monopoly Walk

By far the biggest-selling board game in history (if you discount chess, checkers and backgammon), **Monopoly** *has contributed to endless hours of entertainment, not to mention numerous family arguments! Originally devised in the United States (US), the game took on its iconic status with the introduction of a London version, and the locations in that version have become famous around the world, including the four railway stations.*

There is no particular logic to the selection of locations on the **Monopoly** *board: some sets – such as the Green Set – are all geographically connected, while others – such as the Red Set – have at least one location that is in a completely different area of London.*

This walk takes in the majority of London **Monopoly** *locations, with information about how to reach some of the more out-of-the-way streets and roads. Finally, there are details of where you might be able to spot examples of the pieces used in the game, as you make your way around London.*

Monopoly Walk Introduction

This walk takes in some of the iconic locations of *Monopoly*.

Distance: 5 km. **Approx. number of steps**: 7,500.

Walk note – The *Monopoly* Walk

Although the board game *Monopoly* is closely associated with the streets and roads of London, its origins began in the US, with the creation of a game by Lizzie Magie, which she patented in 1904, with the title *The Landlord's Game*. In 1932 the inventor Charles Darrow came across the game and sold the copyright to Parker Brothers under the name *Monopoly*, even though Lizzie Magie still retained the original patent. She was paid $500 for the rights to her patent, but Darrow went on to make his fortune from *Monopoly*. Parker Brothers were taken over by Hasbro in 1991, thus also acquiring *Monopoly*.

The London version of *Monopoly* was created by Victor Watson, who worked for the Waddingtons games company, after being sent the American version. Together with his secretary, Marjorie Phillips, he travelled to London to rename the locations from the American properties, which went on to be marketed by Waddingtons (see page 191).

There are over 300 official versions of *Monopoly* and thousands of customized ones. There is also a keenly contested *Monopoly* World Championship.

Starting Point

The *Monopoly* Walk starts at Marble Arch, at **nation.care.puppy**. Walk through the arch to start the walk, or Go! in *Monopoly* terminology. The nearest Tube station is Marble Arch. Exit the Tube station, at **libraries.stop.score**, and cross the road diagonally southwest to reach Marble Arch.

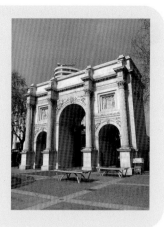

Walk Details

1 From Marble Arch, turn east to join Park Lane, and turn right at **lungs.wink.panels**

Monopoly note – The Dark Blue Set

Park Lane, Mayfair

Although Mayfair is the most expensive property on the *Monopoly* board, there is no actual street with that name. Rather, Mayfair is an area of London on the east side of Hyde Park, with Park Lane being one of its streets. As you walk around this expensive and exclusive area it will soon become clear why it was chosen to represent the most valuable properties in *Monopoly*. However, you will also realise that it would take a lot more than a pocketful of *Monopoly* money to purchase one of these properties in real life.

2 Walk south along Park Lane for 320 metres, with Hyde Park on your right-hand side, to reach Upper Grosvenor Street, at **sudden.filled.save**

3 Turn left into Upper Grosvenor Street. This is the heart of Mayfair, even though there is not actually a street with that name. The area has some of the most exclusive properties in London

Monopoly detour – The Brown Set

Old Kent Road, Whitechapel Road

Because it is the cheapest, the Brown Set is often seen as the poor relation of the *Monopoly* properties. Despite this, or perhaps because of it, Old Kent Road and Whitechapel Road are many people's favourite places to collect. However, both of

them require a detour from the locations on this walk. In real life, Old Kent Road is one of the oldest roads in England and is the only location in *Monopoly* that is south of the River Thames. It can be reached from Bermondsey Tube station, by walking south for 1.5 km along St. James's Road until you reach Old Kent Road, at **model.mash.label**. Whitechapel Road is perhaps also as well known for being the area where Jack the Ripper operated in the 19th century (see page 201) and it can be reached directly from Whitechapel Tube station, at **driven.couches.light**.

4 Continue east along Upper Grosvenor Street for 450 metres and turn left into Grosvenor Square (road), at **spared.hurt.courier**

5 Walk along Grosvenor Square for 150 metres, with the square on your left-hand side, when it becomes Duke Street. Continue along Duke Street for a further 200 metres and turn right into Oxford Street, at **papers.fend.panels**

Monopoly detour – The Light Blue Set

The Angel Islington, Euston Road, Pentonville Road

The Light Blue Set is not found in the very centre of London, although it is only a short Tube ride to Angel Tube station, at **stump.feast.branch**. The Angel Islington has special significance on the London *Monopoly* board as it is the only property location

not named after a street, a road, or an area. Its choice as one of the locations came about when the London board's creator, Victor Watson, and his secretary came to London to find suitable names. They stopped for tea in the Angel Corner House Tea Rooms in Islington and decided that this would merit inclusion on the London *Monopoly* board. To commemorate this event, there is now a *Monopoly* plaque inside the Angel building, which is now the Co-op bank, on Islington High Street, at **cities.rails.maps**. Pentonville Road runs to the west of this location and becomes Euston Road, at **forget.puts.smug**.

Monopoly note – The Green Set

Regent Street, Oxford Street, Bond Street

Covering three of the most
exclusive streets in London, the
Green Set also comprises some
of the finest shopping options
in the city. If your finances can
stretch to it, there are some of
the world's most exclusive shops
here, such as Chanel, Louis

Vuitton, Montblanc, Rolex, and Tiffany. There are also
several department stores on these streets, including
the famous Selfridges, and Hamleys toy store. These
streets are also home to some exclusive hotels, and
not just the *Monopoly* kind. Even if you do not buy
anything in the shops of the Green Set, it can be great
fun window-shopping and looking at some of the
astronomical price tags, if they are even on display.

6 Walk east along Oxford Street for 300 metres,
passing New Bond Street (just Bond Street on the
Monopoly board) on the right-hand side, at
ramp.tanks.native

7 Continue a further
330 metres along
Oxford Street and
turn right into
Regent Street, at
**spicy.grants.
minute**

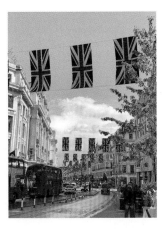

8 Head south along Regent Street, passing Great Marlborough Street (just Marlborough Street on the *Monopoly* board) on the left-hand side, at **eggs.limp. spoon**. Some of the nearby attractions include Hamleys toy store, Carnaby Street and Chinatown

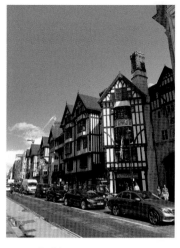

9 From Great Marlborough Street, follow Regent Street for 500 metres and turn right into Man in Moon Passage, at **shut.slim.anyone**

10 Walk through the passage to reach Vine Street, a nondescript street, but one to tick off the list

Monopoly note – The Orange Set

Bow Street, Marlborough Street, Vine Street

Both Vine Street and Marlborough Street are included on the walk (although there is no specific Marlborough Street, but rather Great Marlborough Street) but a short detour is needed to visit Bow Street. From Step 17 on page 196, continue northeast along Strand for 600 metres and turn left into Wellington Street, at **paused.shells.owners**. Walk along Wellington Street for 200 metres to reach Bow Street, at **mouse.angel.truck**.

11 Retrace your steps from Vine Street and continue for 150 metres east along Regent Street, to reach Piccadilly Circus, at **helps.rally.detail**

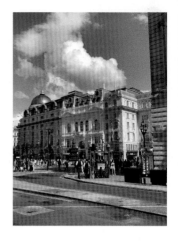

12 Walk around the south side of Piccadilly Circus and walk along Piccadilly, at **rates.club.teach**, until it becomes Coventry Street, at **orange.tame.green**

Monopoly note – The Yellow Set

Leicester Square, Coventry Street, Piccadilly

The locations of the Yellow Set are linked together in a line. Piccadilly extends westwards into Mayfair, and parts of it run along the north side of Green Park. Coventry Street extends from Piccadilly Circus to Leicester Square, and although short, it

includes numerous restaurants and shopping options. Leicester Square is packed full of character, and you can see a number of fun statues on its benches and around its perimeter, including Charlie Chaplin, Mr. Bean, Paddington Bear, Harry Potter, and Bugs Bunny. Leicester Square is also near to London's Chinatown, situated to the northwest, around the pedestrianised Gerrard Street, at **focal.dull.holly**.

13 Continue east along Coventry Street for 200 metres until you reach Leicester Square, at **cowboy.insist.plant**. This is the heart of London's theatre district, indicated by the statue of William Shakespeare in the centre of the square

14 Walk around the west side of Leicester Square, and walk south along St. Martin's Street, at **single.taxi.valley**. Continue for 200 metres (joining Whitcomb Street) to reach the northwest corner of Trafalgar Square, at **nature.ocean.movies**, just off Pall Mall East

15 Pall Mall extends for approximately 600 metres to the west. Walk along as far as you want and then retrace your steps to Trafalgar Square

16 Walk through Trafalgar Square to reach Strand on the southeast side, at **tennis.decide.slows**

Monopoly note – The Red Set

Strand, Fleet Street, Trafalgar Square

The Red Set is another set that has two properties in close proximity and one further away – in this case, Fleet Street. Formerly the home to the London newspaper industry, Fleet Street is reached by continuing 750 metres northeast along Strand from the detour to Bow Street in the Orange Set. Strand becomes Fleet Street at **renew.raves.curve**.

17 Follow Strand northeast for 75 metres, and turn right into Craven Street, at **clean.dance.libraries**

18 Walk south along Craven Street for 220 metres and turn right into Northumberland Avenue, at **pine.finishing.dime**

Monopoly note – The Pink Set

Pall Mall, Whitehall, Northumberland Avenue

Located at the political heart of London, and a few metres from where the Ordnance Survey says is the centre of the city, the Pink Set contains the government buildings of Whitehall, the exclusive houses and gentlemen's clubs of Pall Mall, and the major thoroughfare that is Northumberland Avenue.

19 Walk west along Northumberland Avenue for 250 metres and turn left into Whitehall, at **poster.rips.harp**, at the south side of Trafalgar Square

20 Walk south for 450 metres along Whitehall, turning left into Richmond Terrace, at **power.went.heave**. Walk to the end of Richmond Terrace and turn right into Victoria Embankment, at **words.birds.milk**

21 Finish the walk at New Scotland Yard, headquarters of the Metropolitan Police, at **buzz. starts.hush**. If you get arrested, Go directly to Jail, do not pass Go, do not collect £200!

Monopoly detour – The Stations

Monopoly produces strong feelings among its players, and collection of the stations is one of the most contentious issues: some people love them and consider them vital to the game, while others will ignore them at all costs.

Regardless, they are an integral part of *Monopoly*, and the four stations can be visited by Tube or train. To keep moving in a continuous easterly direction, start at Marylebone station, at **values.mount.stump**, which also includes the Marylebone Tube station. From here, take the Tube to King's Cross station, at **stand.meals.nurses**, (one stop south on the Bakerloo line, then change onto the Circle line for King's Cross). From King's Cross Tube station, continue on the Circle line to Liverpool Street station, at **twigs.shade.jacket**. Finally, Fenchurch Street station, at **storm.spoken.fans**, does not have a Tube station, but it can be reached from Liverpool Street, by taking the Circle line to Aldgate and then walking west along Aldgate High Street and Fenchurch Street for 400 metres to reach the station.

Spot the *Monopoly* Pieces

The pieces used in *Monopoly* can engender as strong feelings as some of the property locations. The pieces have changed considerably over the years, with some favourites being replaced by new pieces, usually based on a public vote. As of 2017 the pieces are: the battleship, cat, dog, penguin, racing car, rubber ducky, top hat, and T-rex. For the true *Monopoly* fan, another game to play in London is to try to identify versions of the pieces used in the game.

- **Battleship**. The HMS Belfast on the River Thames, at **driven.glee.maker**, definitely meets the criteria of an impressive battleship.

- **Cat and Dog**. The Battersea Dogs and Cats home, at **pets.invite.crest**, near the Battersea Power Station Tube station, has been looking after unwanted dogs, and then cats, since 1860 and continues to do excellent work to this day.

- **Penguin**. London Zoo in Regent's Park, at **pine.grid.less**, has numerous Humboldt penguins, housed in the Penguin Beach exhibit.

- **Racing car**. Kensington showrooms. Although actual racing cars are few and far between, some of the car showrooms in Kensington exhibit the likes of Ferraris, Maseratis and Lamborghinis.

- **Rubber ducky**. Rubber ducks can be found for sale in locations around London, with one of them being the Tower Bridge Engine Room & Shop, at **voter.ridge.sand**.

- **Top hat**. Hotel concierges with top hats can be seen outside some of London's more exclusive hotels, including the Ritz, at **grants.drag.fluid**, and the Savoy, at **drive.count.rungs**.

- **T-Rex**. The Natural History Museum, at **locked.pots.flood**, is home to a reconstructed T-Rex and thousands of other exciting exhibits too.

10 Spitalfields Walk

On a city break to London, it is easy to get caught up with iconic sights such as Big Ben, the Houses of Parliament, and Buckingham Palace. However, the city has much more to offer than these familiar sights, and this walk goes through an area that shows the diversity and variety that can be found in London, just a short distance from the city centre.

The walk explores the Spitalfields area and neighbouring Whitechapel, in the east end of London, and follows streets where immigrants have settled for hundreds of years, helping to shape the character of the area. Sights such as the impressive Christ Church Spitalfields are included, as is the well-known Brick Lane, with its excellent range of local shops, restaurants and eye-catching street art.

Spitalfields and Whitechapel were also the locations for the notorious Jack the Ripper murders in 1888, and the walk identifies locations of these killings to show a very different side to the history of London and its darker past.

Spitalfields Walk Introduction

This walk goes through parts of the east end of London.

Distance: 3.5 km. **Approx. number of steps**: 5,250.

Walk note – Spitalfields

Originally founded outside the city boundaries, Spitalfields in the east end became an area to which immigrants were drawn from around the world. This has included French Huguenots, Jews and the current large Bangladeshi community. This has led Spitalfields to develop a diverse character that, in some ways, mirrors that of London as a whole.

The immigrants to Spitalfields brought with them industries such as silk weaving, and this heritage lives on in the nearby Petticoat Lane clothing market, at **minds.fact.trio**.

Spitalfields and the neighbouring Whitechapel are closely linked and it was here the 19th-century killer Jack the Ripper operated, aided by the squalid living conditions in these areas at the time, caused by a variety of factors, but partly from poverty due to a decline in the weaving industry. Ironically, it was this murderous activity that highlighted these conditions and resulted in considerable improvements, through the mixed efforts of politicians and religious groups.

Modern Spitalfields is now considered a vibrant, diverse community that is attracting considerable development as businesses look to capitalise on its popularity. However, this is not being met with enthusiasm in all quarters as there are concerns that some of the character of the area may be lost.

Starting Point

The walk starts on Whitechapel High Street. The nearest Tube station is Aldgate East. Follow the signs for Exit 2 and turn left out of the Tube station, at **hers.pokers.phones**.

Walk Details

1 From Whitechapel High Street, turn left into Commercial Street, at **fully.token.trail**

Historical note – Jack the Ripper and the Whitechapel Murders

The name "Jack the Ripper" is one that has entered London folklore, but he is certainly not someone to be celebrated. During the latter part of 1888 the person known as Jack the Ripper was responsible for the horrific murders and mutilation of at least five defenceless women, and he brought terror and panic to the east end of London.

Although Jack the Ripper is thought to have "officially" murdered five women, the actual number is likely to be higher, with several other murders in the area at the time thought to be his work too. These are known as the Whitechapel Murders and they are thought to number 11 in total, between 1888 and 91, including the five attributed to Jack the Ripper. Despite endless theories about the identity of Jack the Ripper, it is now extremely unlikely we will ever know the name of this callous murderer. The five murders attributed to Jack the Ripper are known as the "canonical murders" and they are listed here in the order of their locations on the walk, rather than their chronological order.

Historical note: Jack the Ripper – Catherine Eddowes, Mitre Square

The fourth woman to be attributed as one of the victims of Jack the Ripper was Catherine Eddowes, who was murdered on the night of 30 September 1888. This occurred in Mitre Square (near to the current Mitre Street, to the west of Spitalfields, at **cheese.sand.lots**) in the Aldgate district and, although nearby, it was the only murder to take place outside Spitalfields or Whitechapel. It was also one of two Ripper murders that happened on the same evening, the other victim being Elizabeth Stride, who was killed before Catherine Eddowes. The murder of Catherine Eddowes is also notable because of a letter that was sent to the police two weeks after the murder, claiming to be from the killer and containing half a human kidney. The letter was given a certain credence by the fact that Catherine Eddowes had had part of her kidney removed by her killer.

2 Walk north along Commercial Street for 450 metres

Walk note – Commercial Street

Built between 1843 and 57, Commercial Street lives up to its name as it was developed to aid businesses in the area, largely by removing the slum areas that had developed here during the 19th century.

Although the creation of Commercial Street led to the demolition of many of the traditional streets that had been part of Spitalfields, it did create an area where commerce could flourish, and there were soon warehouses, workshops, public houses and even a music hall lining the new street.

3 At **follow.gasp.points** is the imposing Christ Church Spitalfields, on the right-hand side

Historical note – Christ Church Spitalfields

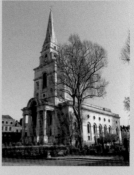

Christ Church is one of the dominant buildings in Spitalfields. It was completed in 1729, as a result of an Act of Parliament in 1710 to build 50 new churches to serve parishes in the rapidly expanding London (only 12 were completed). It was designed by the architect Nicholas Hawksmoor (c.1661-1736) who also designed several more churches in the city. Christ Church has suffered periods of neglect through the years, but was returned to its former glory through a 20-year restoration project that was completed in 2016.

4 A few metres past Christ Church Spitalfields, on the right-hand side, is the Ten Bells pub, at **tunes. ridge.coins**, a location historically linked with Jack the Ripper since at least two of the murdered women frequented the pub

 Continue north along Commercial Street, passing The Golden Heart pub, at **handed.bands.views**

6 Walk a further 450 metres north along Commercial Street and turn right into Bethnal Green Road, at **fuel.spaces.dared**

7 Walk 175 metres east along Bethnal Green Road and turn right into Sclater Street, at **loud.motor.flame**

Walk detour – Shoreditch and Hoxton

To the north of Spitalfields are two of the most fashionable areas in London, Shoreditch and Hoxton. Despite not being wealthy areas of the city, artists and creatives have thrived in both of these areas, and there is a diverse and eclectic restaurant scene. Due to this, Shoreditch in particular has become popular with social-media influencers.

8 Continue 215 metres east along Sclater Street and turn right into Brick Lane, at **wipes. exams.unwanted**

9 Walk south along Brick Lane for 350 metres to reach Hanbury Street, passing the former Truman Brewery and its chimney, at **code.steer.copy**. Founded in the 17th century, the brewery was one of the largest and most successful businesses in Spitalfields and the main employer in the area until it closed as a brewery in 1989. It has since been developed as an artistic centre

Historical note: Jack the Ripper – Annie Chapman, Hanbury Street

Annie Chapman was the second official victim of Jack the Ripper, and her body was found in Hanbury Street on the morning of 8 September 1888, in what was one of the most overcrowded and notorious areas of Spitalfields. Annie Chapman had been drinking in the Ten Bells pub, at **tunes.ridge.coins**, on the evening before her murder, an establishment with a fearsome reputation at the time, and somewhere that would have served the Ripper's intentions well. Like much of the rest of Spitalfields, the Ten Bells pub has left its infamous reputation behind and is now a popular local institution, serving quality beers, fine wines and cocktails.

 10 Continue south along Brick Lane for 350 metres, taking time to view some of the extensive street art

11 Turn right into Wentworth Street, at **trains.boats.keen**

Refreshment stop – Street Food

Throughout Spitalfields there are numerous street-food vendors that add colour and excellent food to the area. There are numerous Asian and Middle Eastern options on offer and they make a tasty, good-value lunch or snack.

Error

 ## Historical note: Jack the Ripper – Elizabeth Stride, Henriques Street

The murder of Elizabeth Stride was the first of two murders on the night of 30 September 1888, with the second one being the murder of Catherine Eddowes. The attack took place in Berners Street, which has since been destroyed and is now Henriques Street, at **rash.noses.miss**. Although Elizabeth Stride had her throat cut, she was not mutilated in the same way as some of the other Ripper victims, leading to some theories that the killer was disturbed, which is why he felt the need to kill again on the same night.

 Walk 100 metres west along Wentworth Street to reach Flower and Dean Walk on the right-hand side, at **flats.dating. human**, which is near to where it is thought that Jack the Ripper lived, even though his identity was unknown

Historical note: Jack the Ripper – Mary Nicholls, Durward Street

The first official victim of Jack the Ripper was Mary Nicholls, also known as Polly. Her mutilated body was found on 31 August 1888 in what was Buck's Row, but has now been redeveloped as Durward Street, at **rice.faded.tape**, behind Whitechapel Tube station. Mary Nicholls was killed by a cut to her throat, and her abdomen was also badly mutilated. On the night of her murder she had been unable to use her regular lodging house as she did not have enough money. She was therefore left on the streets, in a dangerous area of Whitechapel, where she fell victim to the Ripper.

13 Retrace your steps and turn right into Osborn Street (which extends south from the end of Brick Lane) and turn left into Whitechapel High Street, at **taxi.vanish.feed**

14 Continue 775 metres east along Whitechapel High Street (which becomes Whitechapel Road), passing the vibrant street market, at **just.down.watch**, to reach the end of the walk at Whitechapel Tube station, at **driven. couches.light**

Walk detour – Jack the Ripper Museum

The myth and legend of Jack the Ripper has spawned a whole industry of books, tours, TV shows and movies, and also the Jack the Ripper Museum. It is located on Cable Street in Whitechapel, at **intelligible.gallons. worry** (very near to where

the murder of Elizabeth Stride took place). To get to the museum, walk south for 550 metres along Leman Street from Aldgate East Tube station. Go through the tunnel underneath the railway lines and turn left into Cable Street, at **flat.belts.strain**, to reach the museum, which includes recreations of areas where some of the murders took place.

More Spitalfields Locations

Some other sights to look out for as you are walking around Spitalfields include:

- **Old Spitalfields Market**, at **kinks.rally.chin**. A thriving covered local market that not only has a fine range of dining and shopping options, but also a program of live events and artistic exhibitions.

- **Fournier Street**, at **activism.stews.stable**. Formerly named Church Street, this is one of the main streets in Spitalfields and one that retains good examples of the high-quality Georgian housing that was built in the 18th century and inhabited by some of the wealthier silk-factory owners in the area.

- **Grey Eagle Graffiti Wall**, at **fool.buck.sleepy**. One of the largest examples of the street art that can be seen throughout much of Spitalfields.

- **Whitechapel Gallery**, at **towns.hype.cuts**. A public art gallery aimed very much at education and the local community, with exhibitions, talks, movies and workshops. It also includes an excellent library and café.

Index